THE LONDON, MIDLAND SCOTTISH RAILWAY

—— VOLUME 2 ——

PRESTON TO CARLISLE

Stanley C. Jenkins & Martin Loader

AMBERLEY

ACKNOWLEDGEMENTS

The photographs used in this publication were obtained from the Lens of Sutton Collection or from the authors' own collections.

A Note on Opening & Closure Dates

It was normal, in Victorian times, for new railways to be ceremonially opened by the running of a 'first train'. For example, the main portion of the Lancaster & Carlisle Railway was officially opened on 15 December 1846 which, to contemporaries, would have been the opening date. However, as regular public services did not commence until 17 December, it could be argued that the L&CR had two opening dates!

British Railways closure announcements referred to the first day upon which services would no longer run, which would normally have been a Monday. The final day of operation would usually have been the preceding Saturday or Sunday; in other words, the closures concerned would take place on a Saturday or Sunday, and with effect from the following Monday.

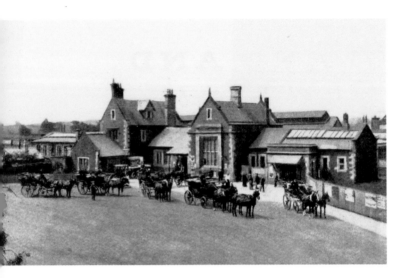

A view of Penrith station at the end of the Victorian period.

First published 2015

Amberley Publishing
The Hill, Stroud, Gloucestershire, GL5 4EP
www.amberley-books.com

Copyright © Stanley C. Jenkins & Martin Loader, 2015

The right of Stanley C. Jenkins & Martin Loader to be identified as the Authors of this work has been asserted in accordance with the Copyrights, Designs and Patents Act 1988.

ISBN 978 1 4456 4387 8 (print)
ISBN 978 1 4456 4414 1 (ebook)

British Library Cataloguing in Publication Data.
A catalogue record for this book is available from the British Library.

Typesetting by Amberley Publishing.
Printed in Great Britain.

HISTORICAL INTRODUCTION

The West Coast Main Line from Euston to Glasgow is one of the most famous rail routes in Britain, if not the World. With its various loops and branches, this major traffic artery links huge conurbations such as London, Birmingham, Liverpool, Manchester and Glasgow, yet at the same time the line passes through lush rural countryside and tracts of wild moorland. The West Coast line has, moreover, always been regarded as something of an 'international' route – Anglo–Scottish expresses such as the *Royal Scot* having a particularly glamorous public image.

Notwithstanding its importance as a major traffic artery, the West Coast Main Line was built in piecemeal fashion by a number of separate companies, including (from London northwards) the London & Birmingham Railway; the Grand Junction Railway; the Manchester & Birmingham Railway; the North Union Railway; the Lancaster and Preston Junction Railway; the Lancaster & Carlisle Railway; and the Caledonian Railway. This present study will examine just two of these early lines – the Lancaster and Preston Junction Railway and the spectacular Lancaster & Carlisle Railway, which surmounts Shap Summit on its way through the Cumbrian Mountains.

THE LANCASTER AND PRESTON JUNCTION RAILWAY

Steam railways originated during the early nineteenth century, the obvious success of pioneering lines such as the Stockton & Darlington and Liverpool & Manchester railways having ensured that ambitious landowners and entrepreneurs were keen to see the advantages of rail communication brought to their own towns and cities. Preston was one of the first towns in England to promote its own rail links, and on 22 April 1831 The Preston & Wigan Railway was incorporated by an Act of Parliament, with powers for the construction of a railway between Preston and the neighbouring Wigan Branch Railway, some fifteen miles to the south. In the event, financial problems compelled the Preston and Wigan promoters to merge their undertaking with the neighbouring Wigan Branch Railway, the amalgamated company being known as The North Union Railway.

The Wigan Branch Railway was brought into use on 3 September 1832, and the Preston and Wigan section was ceremonially opened on Sunday 21 October 1838 – the Preston line being treated an extension of the Wigan route. Public services began on 31 October, and Preston thereby gained a direct rail link to Liverpool, Manchester and London. The success of the North Union Railway was a source of encouragement for other railway promoters, and in April 1836 a public meeting was held in Lancaster town hall to discuss the construction of the grandiloquently-named Lancaster and Preston Junction Railway, which would form a northwards continuation of the North Union main line from its terminus at Fishergate to the historic county town of Lancaster.

The necessary Act of Parliament was obtained on 5 May 1837 (7 Wllm. cap. 22), and with few physical obstacles to impede their work the railway builders made rapid progress, the twenty mile line being more or less completed by the early months of 1840. The line was engineered by Joseph Locke (1805–60) who, with Brunel and the Stephensons, was regarded as one of the greatest engineers of his day. The new railway was laid partly on cross sleepers and

partly on stone blocks, and its steepest gradient was no more than 1 in 500. The line was ceremonially opened between Preston and Lancaster (Penny Street) on 25 June 1840, while regular services began on the following day.

In 1842, the Lancaster Canal Co. secured a lease of the Lancaster and Preston Junction Railway, and for the next few years all L&PJR trains were operated by the canal company. The Lancaster Canal was a well-managed undertaking, but there were suspicions that the canal company was more interested in waterways than in running an effective train service. Indeed, the Preston to Lancaster line soon became the weakest link in the chain of railways between London and Carlisle, the methods of operation in force on that section being chaotic and disorganised.

THE LANCASTER & CARLISLE RAILWAY

In its original form, the Lancaster and Preston Junction Railway was little more than a local branch line, but the completion of railway communication between London and Scotland was regarded as a matter of national importance, and in the L&PJ line soon featured in a variety of extension schemes, notably the Lancaster & Carlisle Railway which was formed in the 1840s, following a series of promotional meetings that had been held in towns such as Lancaster and Kendal.

As first proposed, the Lancaster and Carlisle scheme would have been a relatively modest project, but some of the more far-sighted promoters envisaged the construction of a major Anglo-Scottish main line that would place Lancaster, Kendal and Penrith in direct communication with distant towns and cities such as London, Manchester and Glasgow. The leading supporters of the scheme included Cornelius Nicholson (1805–89) of Kendal, Edward W. Hasell (1796–1872) of Dalemain near Penrith, and Henry Howard of Greystoke near Penrith. Considerable support also came from William, the third Earl of Lonsdale, whose country seat was at Lowther Park, to the south of Penrith.

After much vacillation concerning the route of the line, a parliamentary bill seeking consent for the construction of a railway from Lancaster to Carlisle was prepared for submission in the 1844 session. The L&CR Bill had a relatively easy passage through Parliament, and the 'Act for Making a Railway from Lancaster to Carlisle' received the royal assent on 6 June 1844 (7 & 8 Vic. cap. 37). In the meantime, the promoters had already made preparations for the construction of their line.

Running for seventy miles across difficult terrain, the Lancaster and Carlisle project was, by any definition, a major scheme. To pay for its construction the promoters were authorised to raise the sum of £900,000 in shares and a further £300,000 by loan, although the Grand Junction Railway and other companies had agreed to subscribe a combined total of £480,000. The engineer was Joseph Locke, while the contract for construction of the line was awarded to Messrs Stephenson, MacKenzie and Brassey with the contract price being £591,605.

The authorised route commenced at Lancaster by a junction with the Lancaster and Preston Junction Railway and, passing to the east of the town, the line continued northwards via Oxenholme, Tebay, Shap and Penrith. There was considerable dissatisfaction regarding the proposed route around Lancaster, and on 21 June 1845 the L&CR company obtained a new Act (8 & 9 Vic. cap. 83) authorising a westwards deviation through Lancaster. This change of plan would bring the railway nearer to the town centre but, at the same time, it would entail the construction of a massive viaduct over the navigable part of the River Lune, which would have to be high enough to clear the masts of the tallest ships.

The first sod was cut near Tebay on 18 July 1844, and construction was soon under way at various points. Over 3,500 men were soon hard at work along the seventy mile route, and at the start of the following year it was reported that the ground had been broken in seventy-five places. A quarter of the material had been removed from the heaviest excavations near Shap summit, and the viaducts and other major works were said to be 'well advanced'. In the following November the L&CR directors agreed that the new railway would be built as a double-track main line, this decision being taken on the assumption that the route would eventually be extended northwards to Glasgow by other companies.

As a general rule, the navvies who built railways such as the Lancaster and Carlisle line were agricultural labourers who had left the land to obtain better paid work elsewhere. Detailed studies have suggested that many of the early navvies were recruited locally, though large numbers were Irishmen who became part of an itinerant army of specialist railway builders. Religious differences and political grievances frequently led to trouble between groups of Irish, English and Scottish navvies, and experienced contractors such as Thomas Brassey tried to keep the rival nationalities well apart from each other. There was, nevertheless, much violence during the construction of the L&CR route.

The most notorious incident took place at Penrith in February 1846. The trouble is said to have started when an Irish navvy refused to take instructions from an English ganger, although in retrospect it is perhaps more likely that the Irishmen had been angered by the violently anti-Catholic sentiments of their Scottish workmates. Whatever the underlying reason, a group of English navvies decided to wreck the Irishmen's hutted encampment near Penrith, and in retaliation about 500 Irish navvies marched into the English navvies' camp and chased them from the works. On the following day, no less than 2,000 enraged Englishmen descended on Penrith and proceeded to smash-up the town.

Meanwhile, at nearby Kendall, a group of distressed Irish navvies appealed to Cornelius Nicholson for protection after Scottish navvies had looted and burned their huts. The disturbances were, by that time, so serious that the Westmorland and Cumberland Yeomanry were called out to restore order. The sudden appearance of the Yeomen Cavalry may well have saved the life of an Irish navvy who was being severely beaten by an English thug called John Hobday. Hobday was promptly arrested and, having been tried in Carlisle, he was sentenced to fifteen years transportation to the colonies.

Despite these alarming incidents, the railway was completed in a little over two years. Using picks, shovels, horses and gunpowder, an army of rough, ill-disciplined navvies had achieved a major feat of civil engineering in harsh and difficult conditions. For mile after mile, the raw new cuttings and earthworks sliced through the landscape. Stations were provided at intervals and these were equipped with distinctive Tudor-gothic style buildings that had been designed by the architect William Tite (1798–1873). Carlisle station (which was not completed until 1848) was built on a grandiose scale, though the smaller stations at Penrith and Lancaster were also of considerable pretension.

The first section of the Lancaster & Carlisle Railway was opened between Lancaster and Kendal Junction (later Oxenholme) on Tuesday 21 September 1846, the official First Train being hauled by the 2-2-2 locomotive *Dalemain*. Three months later, on 15 December 1846, the railway was ceremonially opened throughout to Carlisle, an inaugural train of nine coaches being run between Lancaster and Carlisle, again behind the locomotive *Dalemain*. The first train left Lancaster at about 11.00 a.m., and

having called en route at Penrith, the special arrived in Carlisle at 3.30 p.m. In the meantime, a special up working had run from Carlisle to Penrith, where it met the main northbound working. Regular public services commenced two days later, on 17 December 1846, with an initial service of just two trains each way between Lancaster and Carlisle.

FORMATION OF THE LONDON & NORTH WESTERN RAILWAY

Although the newly completed Lancaster & Carlisle Railway was an independent undertaking with its own chairman and board of directors, the line was merely one part of an important chain of railways which, between them, formed the West Coast Main Line. As we have seen, much of the Lancaster and Carlisle's capital had been subscribed by the Grand Junction Railway and other west coast companies, the most important of which was the London & Birmingham Railway.

A few months before the opening, in July 1846, the Grand Junction and London & Birmingham railways had been amalgamated to form The London & North Western Railway, and the newly created LNWR Company thereby became a major shareholder in the Lancaster & Carlisle Railway. The latter undertaking nevertheless retained its nominal independence for several years; the L&CR became part of the LNWR in 1859, and in 1879 a full and final amalgamation was effected under the terms of a London & North Western Railway Additional Powers Act that received the Royal Assent in that year (42 & 43 Vic. cap. 142).

In the meantime, the Lancaster & Carlisle Railway had managed to obtain control of the Lancaster Canal Co. and all its assets, including the Lancaster and Preston Junction Railway – which was thereby brought into the London & North Western fold. Until that time, local trains between Preston and Lancaster had run to and from the L&PJR terminus at Lancaster Penny Street, but with the

L&PJR line under new management most passenger workings were diverted into the L&CR station at Lancaster Castle. Thereafter, Penny Street was used mainly for goods traffic, and in this form in remained in use for many years.

EXPANSION OF THE SYSTEM AROUND LANCASTER AND MORECAMBE

The Lancaster & Carlisle Railway was conceived as an important main line connecting major centres of population, and there was, at first, little thought of constructing branch lines. However, small towns such as Kendall had been by-passed by the L&CR and, for this reason, a number of branch lines were subsequently built – the first one being The Kendal & Windermere Railway, which was authorised on 30 June 1845 with powers for the construction of a 10-mile branch from Oxenholme to Windermere. The line was opened as far as Kendal on 22 September 1846 and completed throughout to Windermere on 20 April 1847.

Meanwhile, other companies had appeared in the area, one of these being the so-called 'Little' North Western Railway, which was authorised on 26 June 1846 with powers for the construction of a railway commencing at Skipton by a junction with the Leeds & Bradford Railway and terminating at Low Park near Kendal, by a junction with the Lancaster & Carlisle Railway, with a branch to Lancaster. The first section of the 'Little' North Western Railway was opened between Skipton and Ingleton on 30 July 1849 while, in the west, a separate section was ceremonially opened between Lancaster and Wennington on 31 October 1849 – though public opening did not take place until 17 November.

At Lancaster, the new works included a wooden viaduct across the River Lune with ten 50-foot spans. By means of this bridge, NWR trains were able to reach the nearby seaside village of Poulton over the metals of the Morecambe Bay Harbour & Railway Co.

This last-mentioned section of line had been opened between Poulton and Lancaster Green Ayre on 12 June 1848, and although initially owned by a separate company, it was worked from its inception by the 'Little' North Western Railway; in later years, Poulton would become better known as the seaside town of Morecambe.

A further branch line appeared on 19 December 1849, when a sharply-curved and steeply-graded connecting line was brought into use between Lancaster Green Ayre station and Castle station. 'Little' North Western trains were then able to run in connection with those on the Carlisle main line, 'a very satisfactory arrangement' having been made for the interchange of traffic between the two stations at Lancaster. The 'Little' North Western was extended eastwards from Wennington to Bentham on 2 May 1850, and completed throughout to Clapham on 1 June. On that day a service of passenger trains was inaugurated between Leeds and Poulton, and the branch from Clapham to Ingleton was closed. It was envisaged that, as receipts improved, the Ingleton branch would be reopened and extended northwards to its intended junction with the Lancaster and Carlisle line, though in the event the missing link between Ingleton and Low Gill was constructed under LNWR auspices and opened on 16 September 1861.

The 'Little' North Western was, at first, regarded as a natural ally of the Lancaster & Carlisle Railway, and it seemed possible that the line might have fallen under LNWR influence. Unfortunately, there was ill feeling between the two companies, and the 'Little' North Western directors therefore formed a new alliance with the Midland Railway, which started to work the 'Little' North Western route in 1852. In the next few years the line from Skipton to Morecambe became an integral part of the Midland system – although the NWR remained in being as a legal entity, and the final Midland takeover did not take place until January 1871.

Several decades later, in September 1904, the Midland Railway opened a further line from Morecambe to new port facilities at Heysham Harbour. In connection with this ambitious scheme, the company provided a fleet of four fast steamers for service on the cross-channel routes to Belfast and the Isle of Man. In a related development, the lines from Heysham to Morecambe and thence to Lancaster were electrified in 1908, power for the new 6,600 olt AC overhead system being supplied by a Midland Railway generating station that had already been built at Heysham Harbour to serve the needs of the new port.

DEVELOPMENTS AT CARNFORTH – THE FURNESS LINE AND THE F&MJR

Poor transport facilities had hindered the development of Lakeland industry for many years, the difficulties being particularly severe in the Furness district. Coastal transport offered a partial solution to this problem, but improved land transport links were desperately needed, and in this context the Furness Railway was promoted as a link between Barrow-in-Furness and the outside world.

In the interim, John Abel Smith, a London banker, had purchased Roa Island with the aim of building a deep water pier to facilitate the export of local ore. At the same time, he was intimately connected with an undertaking known as The Preston & Wyre Railway & Harbour Co., which was developing another rail-connected port at Fleetwood. There was, at that time, no direct rail link between London and Scotland, and in these circumstances there was much interest in the concept of a combined rail-sea route which would incorporate a ferry crossing between Barrow and Fleetwood – the proposed port developments at Roa Island and Fleetwood being an integral part of this grand design.

In view of John Abel Smith's entrepreneurial activities, the Furness promoters decided that their railway should serve Piel Pier, and on

23 May 1844 an Act for railways from Piel Pier to Kirby and to Dalton received the royal assent. The new railway was opened for goods traffic in June 1846, the official opening being celebrated on 12 August 1846, while regular services started twelve days later. In its original form, the Furness Railway was a Y-shaped system, with one line extending northwards to Kirby and another arm running north-eastwards to Dalton. The two arms converged at a point known as Millwood Junction – from where the main line continued southwards to Piel Pier, while a short branch ran westwards from Roose Junction to Barrow.

Having started life as an entirely self-contained route, the Furness Railway was subsequently extended and linked-up with neighbouring lines to form part of a continuous chain of railways around the Cumbrian coastal districts. On 27 July 1846, the company obtained Parliamentary consent for a northwards continuation to Broughton-in-Furness and an eastwards extension to Ulverston. These new lines were opened in February 1848 and 7 June 1854 respectively – the Broughton line being linked to Whitehaven when the neighbouring Whitehaven & Furness Junction Railway was completed on 1 November 1850. The Ulverston route opened on 7 June 1854, by which time The Ulverston & Lancaster Railway had been sanctioned with the aim of linking-up the Furness Railway with the Lancaster & Carlisle Railway main line at Carnforth.

The Ulverston & Lancaster Railway was opened for goods traffic on 10 August 1857 and for passengers on 26 August. This new line was of immense importance to the Furness Railway in that it formed the final link in a chain of coastal railways connecting Ulverston, Barrow, Whitehaven, Workington and Carlisle. The Ulverston & Lancaster line was worked by the Furness Railway as an extension of its Barrow-in-Furness to Ulverston route, the old terminus at Ulverston becoming part of an enlarged goods yard. At Carnforth, the new line converged with the L&CR main line via a connection on the down side, and

Carnforth thereby became a 'joint' station with separate platforms for London & North Western Railway and Furness Railway services.

When completed in 1850 the 'Little' North Western line functioned as a cross-country route between Morecambe and the industrial districts of West Yorkshire, but the NWR route was much less convenient as a link between Yorkshire, the Lake District, and Barrow Docks. It was therefore decided that a 9-mile connecting line would be constructed between the Furness route at Carnforth and the 'Little' North Western line at Wennington. The proposed line was a Joint venture between the Furness and Midland railways, the required capital of £150,000 being provided in equal proportions by the parent companies. The F&MJR scheme received the royal assent on 22 June 1863 and the railway was opened on 6 June 1867. The Furness and Midland joint line had intermediate stations at Melling, Arkholme, and Berwick, and the principal engineering feature was a 1,200-yard tunnel between Wennington and Melling.

The junction arrangements at Carnforth were peculiar insofar as through trains to Barrow joined the earlier Ulverston & Lancaster (Furness) route on the west side of the station, whereas terminating services crossed the West Coast Main Line to the north of the station and made use of a tightly-curved connecting spur that provided a means of access to the platforms. There were no through platforms, and for this reason it became the practice for Midland Railway through coaches to be attached or detached at Carnforth East Junction.

CONNECTING LINES AT PENRITH – THE STAINMORE ROUTE AND THE CK&PRE

The North Eastern Railway was one of the major pre-Grouping companies. It traced its origins back to the pioneering Stockton & Darlington Railway, which claimed to have been the World's first public steam-worked railway, having commenced regular steam-hauled passenger services in 1833. The line was gradually extended

during the next few years, Bishop's Auckland being reached in 1843, while in 1856 the route was further extended to serve Barnard Castle. Ambitious entrepreneurs were soon planning a variety of additional lines, one of which was the South Durham & Lancashire Union Railway. The scheme was designed to link Bishop Auckland and Tebay, so that Durham coal and coke could be easily transported to the ironworks of Furness. Engineered by Thomas Bouch, the railway was opened for freight traffic on 4 July 1861, and for the carriage of passengers on 8 August 1861. The route was spectacular, with fearsome gradients on both sides of Stainmore summit, and a huge lattice girder viaduct at Belah, near Kirkby Stephen.

Meanwhile, in 1858 the Eden Valley Railway had obtained an Act for construction of a railway commencing at Kirkby Stephen on the South Durham & Lancashire Union Railway and terminating at Clifton by a junction with the Lancaster and Carlisle main line. The Eden Valley line was opened for mineral traffic on 10 April 1862 and for passengers on 7 June. The Eden Valley company was taken over by the Stockton & Darlington Railway at the end of June 1862, while in 1863 the S&DR was itself absorbed by the North Eastern Railway. The lines from Darlington to Penrith and Tebay thereby became appendages of the NER Company.

The completed Stainmore route was soon carrying significant quantities of Durham coal to the Furness iron-producing district, but it was realised that a westwards extension from Penrith to the Cumbrian coast would be of immense advantage to the Cumberland iron industry. Such a line would enable Durham coking coal to reach Cumberland furnaces, while in the reverse direction, it was expected that Cumbrian iron ore would flow eastwards to the North Eastern industrial areas.

An Act for construction of the Cockermouth, Keswick & Penrith Railway was obtained on 1 August 1861 (24 & 25 Vic. cap. 203).

The authorised line would commence at Cockermouth by a junction with the Cockermouth & Workington Railway and terminate 'in a field called Miresbeck Field, otherwise Newlands Close at or near Newlands Terrace, in the Parish of Penrith, all in the County of Cumberland'. There would, in addition, be a short branch from the main line to 'a junction with the Lancaster & Carlisle Railway, at a point distant about six hundred and fifteen yards southwards' of Penrith station.

The thirty-one-mile CKP route was opened for goods and mineral traffic on 1 November 1864, and for passengers on 2 January 1865. Although the Cockermouth, Keswick & Penrith Railway was an independent company, it had no locomotives or rolling stock of its own, and for this reason the line was worked jointly by the London & North Western and North Eastern companies. The LNWR provided passenger services between Penrith and Workington, while the NER conveyed Durham coking coal between across the Pennines to West Cumberland and Furness. In the opposite direction, NER freight trains carried pig iron back across Stainmore summit to the East Coast foundries.

SUBSEQUENT DEVELOPMENTS

The LNWR, Midland and Furness railway systems passed into London Midland & Scottish Railway ownership at the time of the 1923 Grouping, and there were thereafter one or two small changes. At Lancaster, for example, the former Midland engine sheds at Lancaster Green Ayre became the main shed for locally-based engines, while at Carnforth the Furness side of the station was rebuilt in a strikingly modern style. Otherwise, the Lancaster & Carlisle line and its connections continued to operate much as they had done during the LNWR era – albeit with the provision of more powerful and modern locomotives such as the Stanier Black Five 4-6-0s and the mighty Coronation class 4-6-2s.

The nationalisation of Britain's railways on 1 January 1948 had little immediate effect on the West Coast Main Line, which continued to operate as a major trunk route linking England and Scotland. Unfortunately, the world was changing faster than the railways; private car ownership, for instance, had become widespread by the 1960s, while at the same time the steam-worked railways were being portrayed in the media as obsolete relics of the Industrial Revolution. Meanwhile, the ruling political party was taking an increasingly pro-road transport stance, and these developments had obvious ramifications for the railway system.

By the early 1960s the Cockermouth, Keswick & Penrith line was said to be losing £1,000 per week, while the long-distance freight traffic that had once sustained the Stainmore route had largely evaporated. The Stainmore route had always been a difficult line to work, its gradient problems being compounded by weight-restricted viaducts such as that at Belah. The line's passenger services were dieselised in 1958, but passenger loading continued to fall, and in January 1962 the route was closed to all traffic between Penrith and Barnard Castle. The last trains ran on Saturday 20 January 1962 and, as usual on such occasions, the final day of operation was commemorated in suitable style, with a special train from Darlington.

Government hostility towards the nationalised railways reached its peak with the publication of the Beeching Report in 1963. The Beeching proposals presaged doom for huge chunks of the railway system, seaside lines and competing routes being singled out for special treatment. As far as the Preston to Carlisle line and its connections were concerned, the Beeching proposals recommended that the Carnforth to Wennington, Lancaster to Heysham and Cockermouth, Keswick Penrith lines should be closed, although the former LNWR branches to Morecambe and Windermere would be retained.

There was in fact an element of indecision concerning the rationalisation of lines in the Lancaster area, and it was finally decided that the Midland route would be closed between Wennington and Morecambe. This alternative plan involved the closure of Lancaster Green Ayre station, leaving Lancaster Castle as the town's only passenger station. Morecambe to Leeds trains were diverted over the former Furness and Midland joint line via Carnforth and the north arm of Bare Lane triangle, though a diesel-worked local service was maintained between Lancaster Castle and Morecambe Promenade via Morecambe South Junction. The closures went ahead as planned with effect from Monday 3 January 1966, from which date an augmented service was provided between Morecambe Promenade and Lancaster Castle. Heysham Harbour lost most of its services, though the line from Morecambe was retained for boat train workings.

In October 1964, the Conservatives were voted out of office after thirteen years of continuous rule, and this resulted in a slow-down in the Beeching closure programme. Early in 1966 Labour Transport Minister Barbara Castle refused her consent for an outright closure of the Cockermouth, Keswick and Penrith line, but she agreed that the line could be closed beyond Keswick. The Keswick to Workington section was duly closed on 16 April 1966, leaving the Keswick to Penrith section as a dead-end branch worked from Penrith. Meanwhile, the West Coast Main Line continued to function as a major traffic artery between England and Scotland, an important development being the extension of the West Coast electrification scheme from Weaver Junction to Glasgow in May 1974.

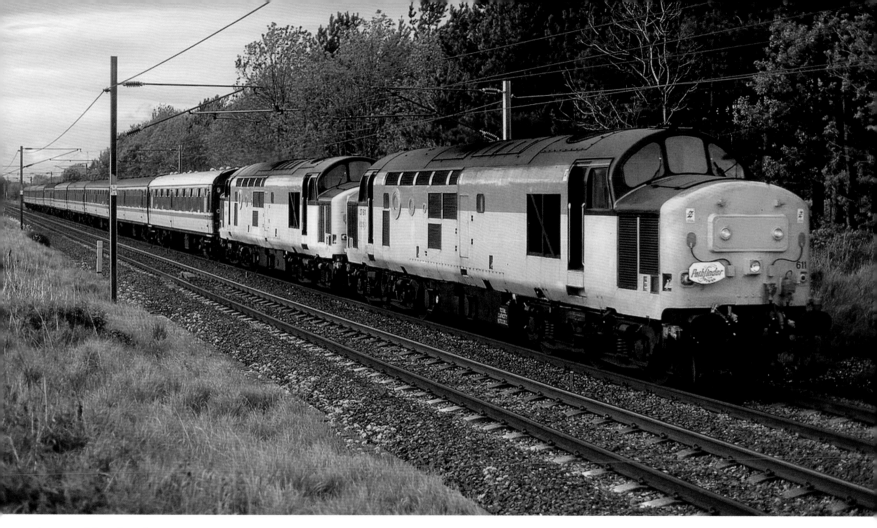

Approaching Brock
Class 37 locomotives Nos 37611 and 37604 speed past Brock, on the Lancaster and Preston Junction section, with the 6.10 p.m. Pathfinder Tours Carnforth to Bristol Temple Meads Cumbrian Coaster rail tour on 1 June 1996.

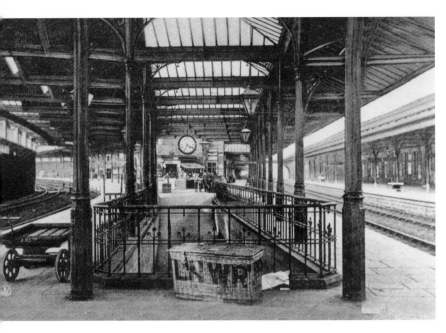

Right: Passing Docker
Class 40 locomotive No. D345 passes Docker, on the Lancaster and Carlisle section, with the 7.12 p.m. Pathfinder Tours Birmingham International to Carlisle Pennine Fellsman rail tour on 12 July 2003.

Left: Carnforth – The Setting for 'Brief Encounter'
An Edwardian postcard view of Carnforth station which, in 1945, was used by David Lean for the filming of *Brief Encounter*.

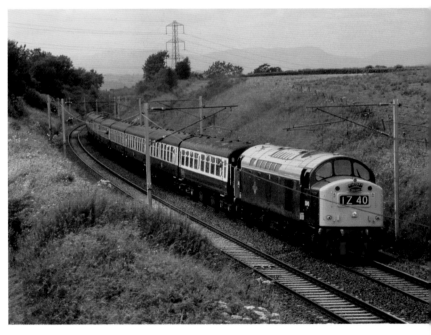

Right: **Map of the Lancaster and Carlisle Line**
A map of the railway system in the north Lancashire and Cumbrian area. The Lancaster and Preston Junction Railway runs northwards in a dead-straight line, while the Lancaster & Carlisle Railway continues towards Scotland via Oxenholme, Low Gill, Shap and Penrith. The now-closed Stainmore route can be seen running eastwards from Penrith, and the Settle and Carlisle route extends diagonally across the map before converging with the L&CR route at Carlisle. Most of the main line routes shown on this map have remained in operation, although several of the branch lines, including the Cockermouth, Keswick & Penrith Railway, have been closed.

Below: **Class 87 Electric Locomotive at Lancaster**
The Class 87 electric locomotives were introduced in 1973 for service on the West Coast Main Line. No. 87018 is pictured at Lancaster Castle station at the head of a Royal Train on 7 May 1974, with the Queen sitting in the cab.

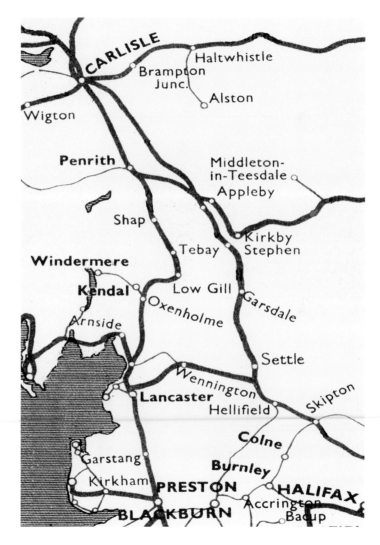

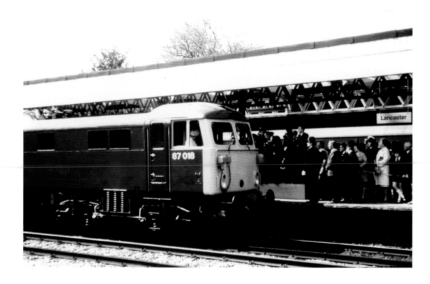

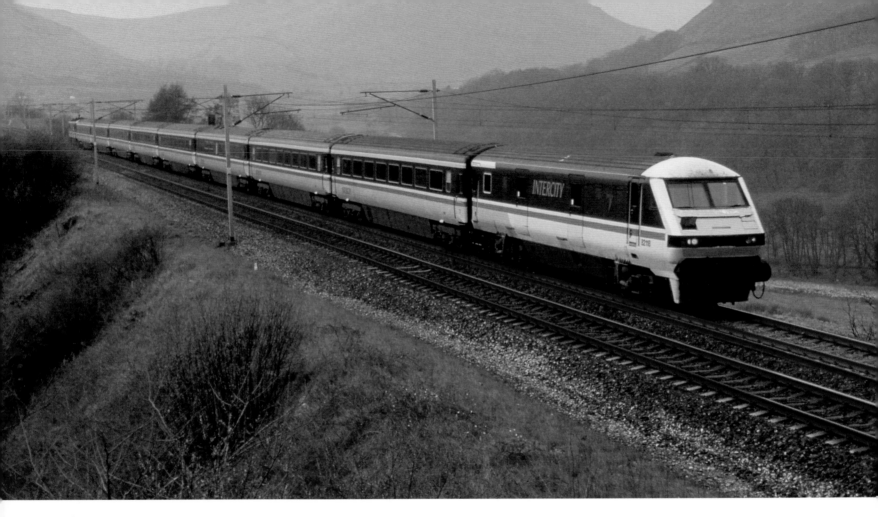

In the Lune Gorge
A classic view, taken at Dillicar in the Lune Gorge on 11 April 1992, as the 3.14 p.m. Euston to Glasgow express speeds northwards, the leading vehicle, No. 82118, being a Driving Van Trailer (DVT) – in other words an unpowered vehicle fitted with a driver's cab that allows locomotives to be driven from the opposite end of their trains.

Preston – Origins of the Station

The railway history of Preston is a story of unusual complexity, involving a bewildering assortment of companies. Furthermore, most of these companies insisted, at one time or another, in providing their own termini, with the result that Preston could boast around half a dozen different stations. The Preston & Wyre Railway, for example, established a terminus at Maudlands, on the east side of the Lancaster and Preston Junction Railway, while the former North Union station was situated on the south side of Fishergate. The Fishergate station was generally regarded as the town's principal railway station, and as the local railway network was gradually consolidated under the joint control of the London & North Western and Lancashire & Yorkshire railways, the NUR station achieved even greater importance.

As originally built, the station was sited in a cutting immediately to the south of Fishergate, its platforms being orientated on an approximate north-to-south alignment. When the Lancaster and Preston Junction Railway was opened in 1838, the tracks were extended northwards beneath Fishergate via a steeply graded 77-yard tunnel, while in 1840 Preston and Wyre Joint Railway was installed about half a mile to the north, giving P&WR services a convenient means of access to the station. Further lines were added to the local railway system in the next few years, bringing extra traffic to what was still a comparatively small station by main line standards. The two photographs on this page show the station during the early years of the twentieth century.

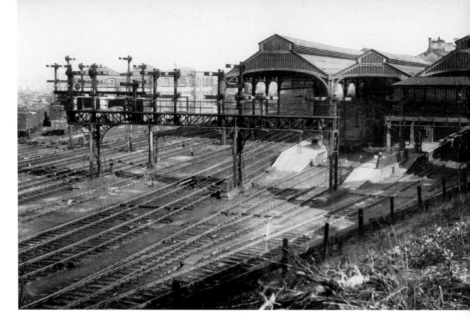

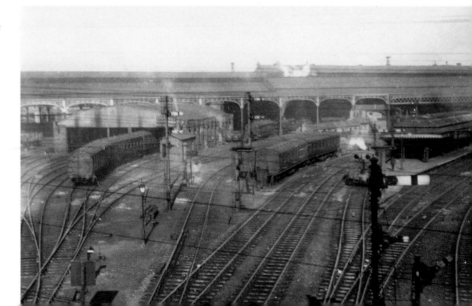

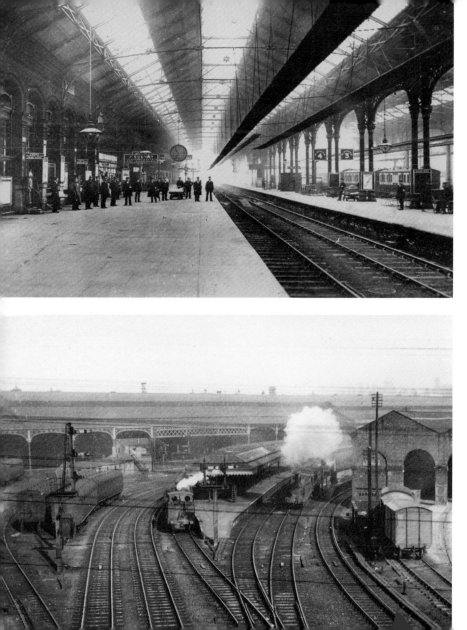

Preston – Rebuilding the Station

In its original guise, Preston station boasted elegant, two-storey buildings in a restrained classical style, together with an overall roof measuring approximately 120 feet by 40 feet. As usual in the early days of rail travel, the platforms were only a few inches above rail level, and it became the practice for travellers to wander about on the running lines. As the years passed, the facilities became increasingly dilapidated, and on one occasion part of the roof collapsed onto the platforms. By the mid-1860s it was universally agreed that the station was an utter disgrace, and on 24 February 1866 The *Lancaster Guardian* complained that the old station, which was 'almost roofless', and had been 'white-washed, patched-up and daubed' in every possible way, was 'the dingiest old shed in railwaydom'.

Powers for the construction of a new station were finally obtained on 4 July 1870, but the new station was not completed until 1880, over ten years having elapsed since the passage of the relevant Act of Parliament. The completed station cost around £225,000, and it was described as 'one of the finest in existence'. Further improvements were carried out in 1902–03, as a result of which the track layout was considerably improved. The upper picture shows the interior of the reconstructed station, while the lower view shows the part of the complex web of track work on the east side of the train shed.

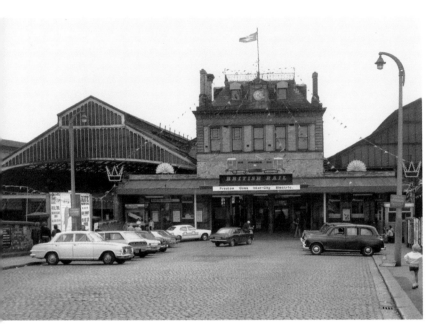

Left: Preston – The Main Station Building

The rebuilt station, which has remained in use until the present day, incorporates a spacious island platform, with additional platforms on either side. The bridge carrying Fishergate across the north end of the station was included in the reconstruction scheme, a long ramp being provided as a means of pedestrian and vehicular access from the street to the central island platform. The island platform is 110 feet wide, and it is equipped with large and substantial buildings; the main entrance building, sited at right angles to the platforms, is situated at the south end of the sloping access ramp, as shown in the accompanying photograph. Having walked down the gentle slope from Fishergate, travellers enter the station's main entrance, and after purchasing their tickets they reach the spacious platforms by means of a long footbridge that extends laterally across the full width of the station.

Right: Preston – Platform Arrangements

The main platforms used by long-distance InterCity services are covered by huge glass and iron train sheds with gable roofs and raised clerestories, while smaller, subsidiary train sheds protect the adjoining platforms. The station buildings are constructed of yellow brickwork with arched window apertures, while the extensive roof coverings are supported by a profusion of ornate ironwork. The platforms have latterly been numbered in sequence, Platforms 1 and 2 on the west side of the station being used by trains to Blackpool, Burnley, Manchester Victoria, Blackburn and Colne, while Platforms 3 and 4 now handle most of the long distance West Coast Main Line traffic. Platforms 5 and 6 deal with services to Barrow-in-Furness and Manchester Airport, but Platform 7, on the east side of the station, is not in regular use. There are, in addition, two north-facing bays, which are numbered 3c and 4c.

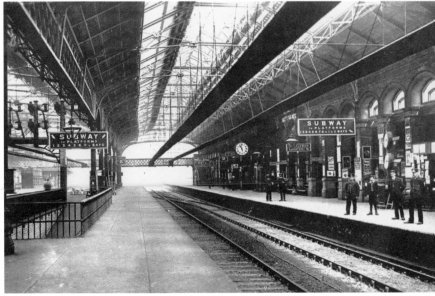

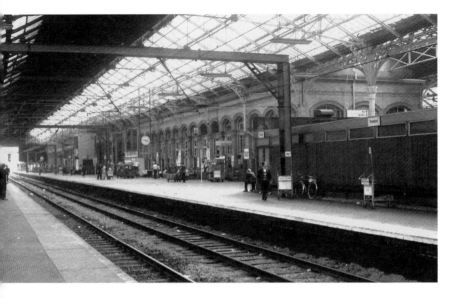

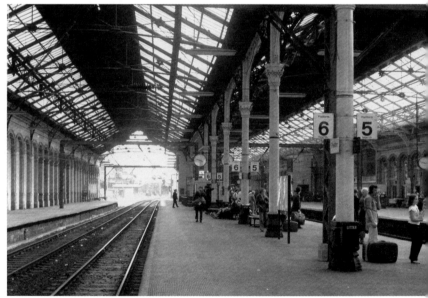

Left: Preston – Platform 4

A general view of Platform, looking south towards Euston and showing the extensive station buildings. Preston has always been a busy station. In the 1860s, it handled around 150 trains on an average weekday, with many extra workings on summer Saturdays. The rise of Blackpool as a popular holiday resort contributed further traffic until, by the 1930s, the station handled almost 1,000 passenger trains a day on summer Saturdays at the height of the holiday season. Although summer excursion traffic had decreased dramatically by the 1990s, Preston continued to handle about 225 passenger services during the course of a typical weekday, including west coast workings, long-distance cross country services and local trains to destinations such as Blackpool, Blackburn, Ormskirk and Barrow. In recent years the station has generated around 4.5 million passenger journeys per annum.

Right: Preston – Platforms 5 & 6

A view of Platforms 5 and 6, on the east side of the station, with the little-used Platform 7 visible to the left. In steam days the station was used primarily by passenger services, although successive editions of the Railway Clearing House *Handbook of Stations* reveal that it was equipped with loading facilities for horses, furniture and road vehicles. Goods traffic was dealt with in Butler Street goods yard, on the east side of the passenger station, while separate coal yards were available at Dock Street and Corporation Street, to the north of the station. Additionally, the long-closed passenger stations at Maudlands, Deepdale and Fishergate Hill were used as goods depots for many years. There were also a number of industrial sidings, including the Preston Docks branch, which diverged from the down side of the main line some twenty-four chains to the south of the passenger station and descended towards the dock area on gradients as steep as 1 in 29. Engineering features included a 145-yard tunnel and curves of 530 foot in radius.

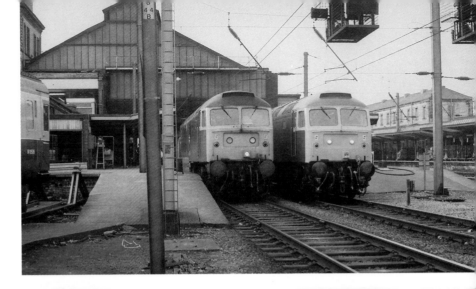

Preston – Changing Locomotives

The West Coast Main Line electrification scheme was completed as far as Preston on 23 July 1973, after which the best trains were able to reach Euston in only two hours forty-three minutes – the fastest times ever between Preston and London. For locomotive enthusiasts, the period between February 1973 and May 1974 was particularly interesting, in that Preston became the usual changeover point between diesel and electric power – the electric locomotives used between London and Preston being replaced by Class 50s or other diesel locomotives for the remainder of the journey to Scotland. The upper picture shows Class 47 locomotives Nos 47568 and 47485 in Platforms 2 and 3, while the lower view shows Class 25 No. 25199 and an unidentified sister locomotive, apparently taking over from a Class 86 electric locomotive. The West Coast electrification scheme was completed on 6 May 1974, when regular 25,000 volt AC electric services began running through from London to Glasgow, the best trains taking five hours for the 401.5-mile journey.

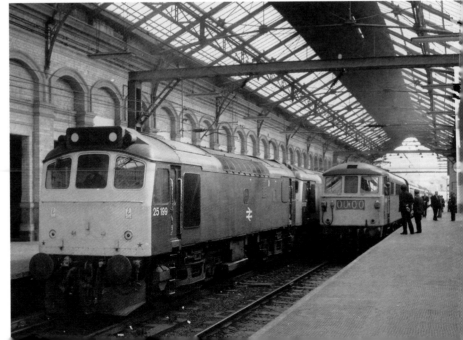

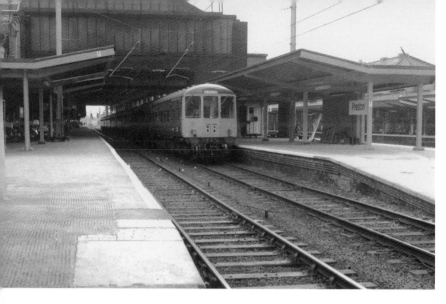

Right: Preston – Diesel Multiple Units

A two-car diesel multiple unit stands alongside the north end of Platform 4 during the mid-1980s. The colour light signals that can be seen in the distance serve as a reminder that the Preston area was re-signalled in connection with electrification during the early 1970s, a new two-storey power signal box being erected to the north of the passenger station on a site that had previously been occupied by the LNWR locomotive depot. The new installation was brought into use on the weekend of 3–5 February 1972, and it controlled the West Coast Main Line between Wigan and Burton and Holme, to the north of Carnforth. This area was later extended to include the East Lancashire route as far east as Hebden Bridge; in all, the new box replaced eighty-seven mechanical boxes, although eleven fringe boxes and token stations were retained.

Opposite: Preston

A panoramic view showing the south end of the station during the LMS period; a former Lancashire & Yorkshire Railway 2-4-2T is engaged in shunting operations in the foreground.

Left: Preston – Diesel Multiple Units

Following electrification in 1974, the best London to Glasgow services were hauled throughout by Class 86 or Class 87 locomotives. Diesel locomotives continued to appear on freight workings and on Blackpool through services, though many local services were handled by diesel multiple units as shown in the 1980s view, which depicts a Class 104 unit, probably on a Blackpool working. Long-distance cross-country workings have become an important aspect of operations at Preston in recent years – popular and comfortable HST sets having been used to provide a range of services to destinations such as Penzance, Bournemouth and Dundee, although many cross-country services are now worked by Voyager units.

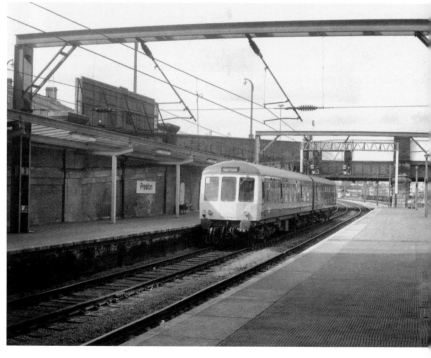

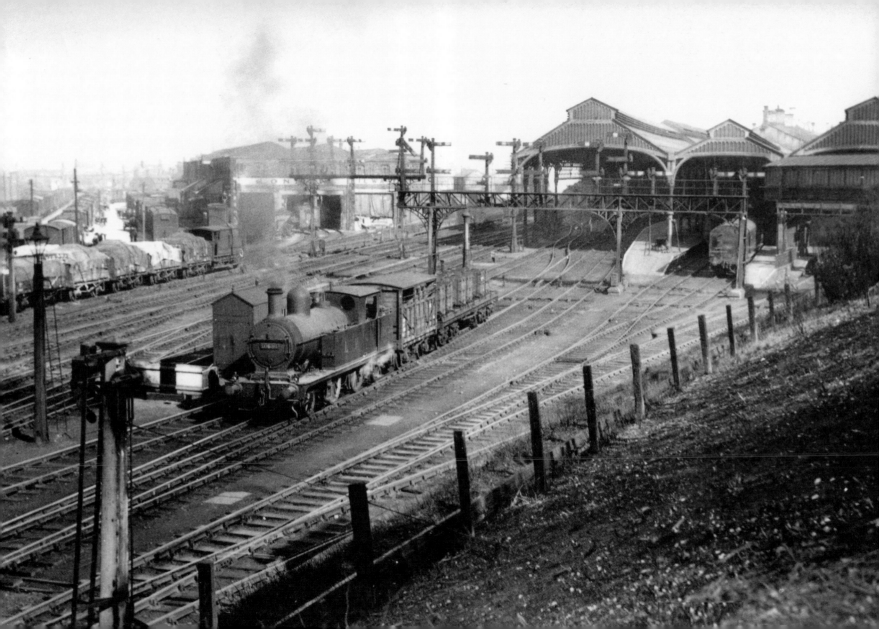

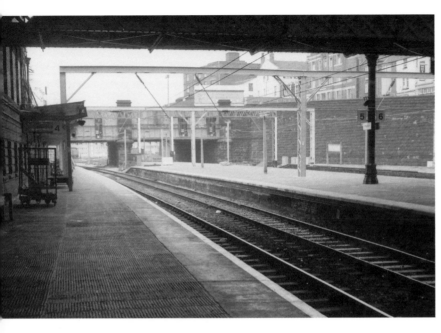

Left: Preston – Platform 4
A further view looking northwards along Platform 4 during the mid-1980s, the Fishergate Bridge being visible in the background.

Right: **Preston – Some Tickets**
A selection of tickets issued at Preston during the 1960s and 1970s, including three platform tickets, five British Railways second class singles and a special cheap day ticket. The white platform tickets are paper issues, whereas the blue-coloured free platform ticket is an Edmondson card. Traditional railway tickets were colour-coded and, in BR days, second-class single and returns were normally printed on grey-green cards, while first-class issues were white and cheap day returns were buff-coloured. Children's tickets were distinguished by the addition of red 'child' overprints.

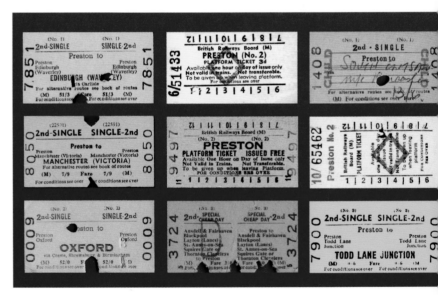

Left: Preston – Via Lostock Hall Junction

An interesting feature of operations at Preston in steam days concerned the system of loops and connections to the south of the station, which formed a circuitous reversing loop that could, if necessary, be used to turn complete trains – this facility being particularly useful when Blackpool excursion trains arrived from the north. There was no facing connection for up trains heading towards Blackpool, but these workings could be routed southwards through the station and thence over the East Lancashire line to Lostock Hall Junction, from where they were able to return northwards as down workings via Farington Curve Junction. Having changed direction, the excursions re-entered Preston from the south and ran through the west side of the station to Preston and Wyre Joint Railway. The picture shows Stanier 8F 2-8-0 No. 48151 drifting past Lostock Hall Junction with the 5.49 a.m. Pathfinder Tours Reading to Carlisle Cumbrian Mountain Express rail tour on 10 May 1997. Class 47 diesel locomotive No. 47634 *Holbeck* is coupled behind the 2-8-0.

Right: Preston – Via Lostock Hall Junction

The independent East Lancashire line into Preston has now been closed, but the retention of a north-to-east curve between Farington Curve Junction and Lostock Hall means that trains from Preston to Blackburn can still run southwards along the West Coast Main Line, turn eastwards, and then cross over the main line at Lostock Hall before continuing eastwards in the direction of Blackburn and Colne. Class 142 unit No. 142012 passes Lostock Hall Junction with the 11.10 a.m. Blackpool South to Colne Regional Railways service on 10 May 1997. Lostock Hall station can be glimpsed in the distance, while the line diverging to the left connects the Preston to Blackburn line with the West Coast Main Line. This route is electrified, which explains why a catenary post is visible to the left, on the adjacent siding. This short spur is useful in that it obviates a reversal at Preston when main line trains are diverted onto the Settle and Carlisle route during weekend engineering work on the West Coast Main Line.

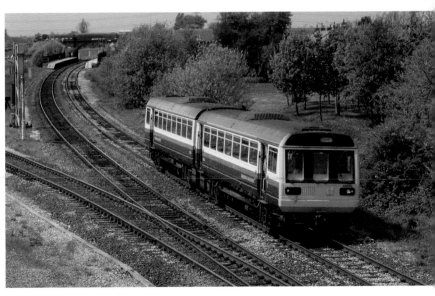

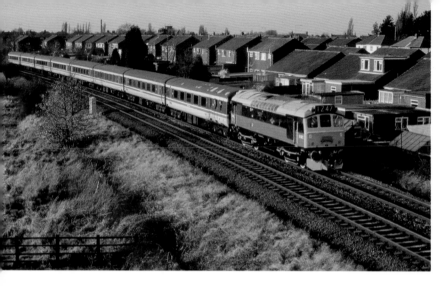

Left: **Preston**

Class 25 locomotive No. D7672 *Tamworth Castle* passes Lostock Hall with the Hertfordshire Railtours Copy Pit Pullman rail tour on 29 December 1990. This enthusiasts' special had started its journey at Euston, with the Class 25 taking over at Preston for the run to Leeds. Following its withdrawal from main line service in 1987 the engine (which had been re-numbered No. 25332 under the TOPS scheme, but had been running as No. 25912 since 1985) was repainted in two-tone green at Leeds Holbeck depot and named Tamworth Castle, a name which it carried for a number of years. After a period in use as a staff training locomotive, the engine was secured for preservation, and it is at present on the Churnet Valley Railway in Staffordshire.

Right: **Preston – Via Lostock Hall Junction**

A six-car multiple unit formation led by Class 101 unit No. 101682 heads southwards past Farington West Junction with the 6.27 p.m. Blackpool North to Buxton North West Regional Railways service on 14 September 1996. These units were built in Birmingham by Metropolitan-Cammell, and they had first been introduced in 1956. The rest of the country was, at that time, busily ridding itself of 'first generation' multiple units, but the Metro Cammell Class 101 sets nevertheless remained in use on local services in the North West for a further seven years.

Opposite: **Preston – Via Lostock Hall Junction**

Class 58 locomotive No. 58011 Worksop Depot catches the last rays of the setting sun as it passes Farington Junction with the 1.45 p.m. Pathfinder Tours Newcastle to Bristol Temple Meads Geordie Choppers rail tour on 14 September 1996. This tour started in Bristol, and it included an outward trip to Newcastle via Preston, Lancaster, Oxenholme and Hexham, and a return journey via York, Leeds and Carnforth – Class 20 locomotives Nos 20304 and 20305 being employed between Preston, Newcastle and Carnforth, while No. 58011 took over for the homewards journey from Carnforth to Bristol.

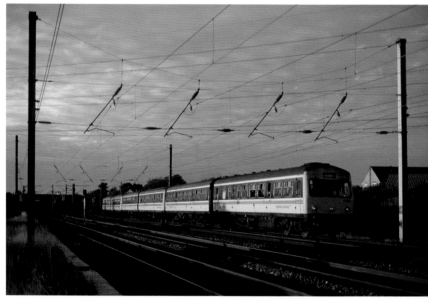

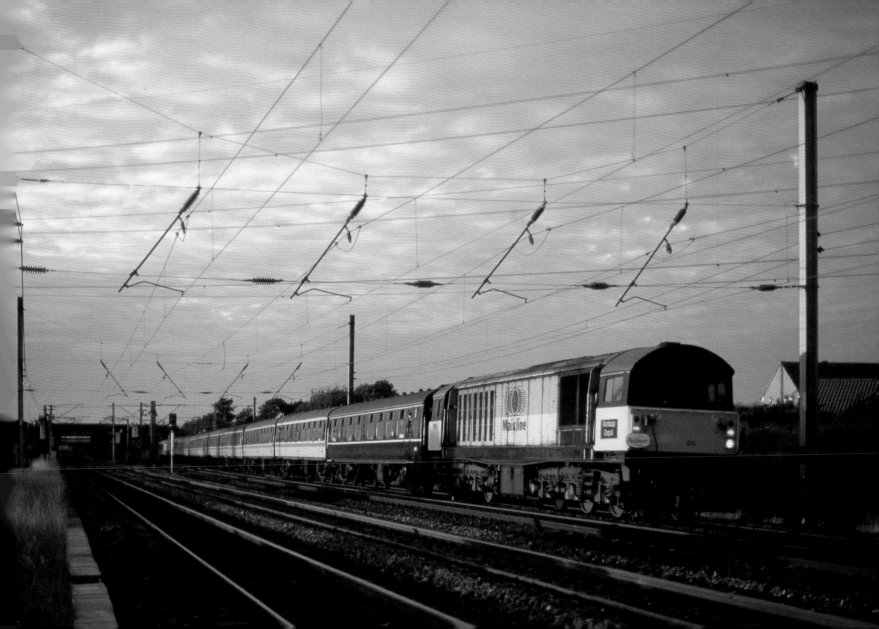

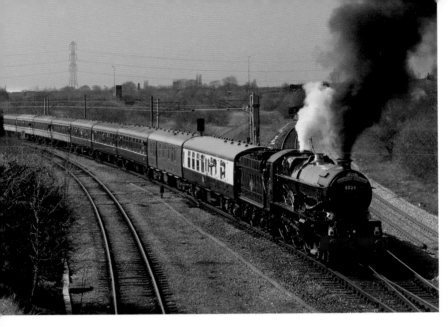

Left: Preston – Via Lostock Hall Junction

Former Great Western Railway King Class 4-6-0 No. 6024 *King Edward I* accelerates away from a brief stop at Lostock Hall Junction while hauling the 5.40 a.m. Pathfinder Tours Swindon to Carlisle Cumbrian Mountain Express rail tour on 28 March 1998. This service ran outwards via the Settle & Carlisle line and returned southwards via Shap and the Lancaster and Carlisle route – the 'King' being employed on the northbound leg between Crewe and Carlisle.

Right: Preston – Lostock Hall and Preston Sheds

There were two important steam sheds in the Preston area, the former LNWR shed being sited were situated to the north of the station on the down side, while an ex-Lancashire and Yorkshire shed was situated at nearby Lostock Hall. On 28 June 1960 Preston shed was severely damaged by fire, four engines being severely damaged, while around 20,000 square feet of roofing was destroyed, and two firemen were injured in preventing the fire from spreading to other buildings. The fire hastened the demise of Preston shed, which was officially closed with effect from 11 September 1961. Its locomotives were then transferred to Wigan Springs Branch, Carnforth and Lostock Hall sheds – although Preston shed remained in use for storage purposes. In the mid-1960s Lostock Hall had an allocation of around thirty locomotives, including Class 5MT 4-6-0s, Class 8F 2-8-0s, Class 4MT 2-6-4Ts and Class 3F 0-6-0Ts. The photograph shows Stanier Class 5MT 4-6-0 No. 45227 outside the shed on 23 May 1964.

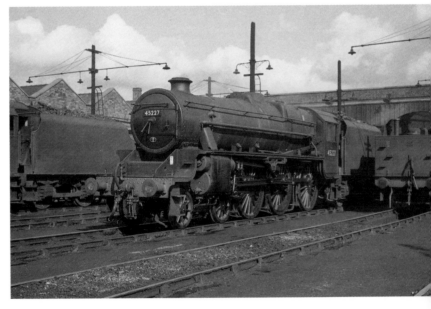

Barton and Broughton

Running in a more or less dead-straight line from Preston to the southern outskirts of Lancaster, the former Lancaster and Preston Junction Railway was a well-engineered route, with no perceptible gradients; it was, and indeed still is, a racing ground over which successive generations of west coast locomotives have been allowed to show their paces across the west Lancashire coastal plain. To allow this fast section to be worked to its fullest potential, several of the intermediate stations between Preston and Lancaster were eliminated during the 1930s, one of the casualties being Barton and Broughton.

This small station had an unusually complex early history. When first opened by the Lancaster and Preston Junction Railway on 25 June 1840, it had been sited at Crow Hall, near Broughton, but it was later decided that the permanent station should be established at School Lane near Barton Hall, about three-quarters of a mile to the north. The re-sited station was officially named Barton and Broughton in April 1861 and, as such, it served the surrounding villages until May 1939 when passenger services were withdrawn.

The upper picture is looking south towards London around 1912, the main station building being visible to the right, while the subsidiary building on the up platform can be seen to the left – the latter structure being a simple, timber-framed waiting shed. The lower view is looking north towards Carlisle with the station building to the left; the absence of any posters and timetables on the large notice board suggests that this 1930s photograph may have been taken shortly after the withdrawal of passenger services.

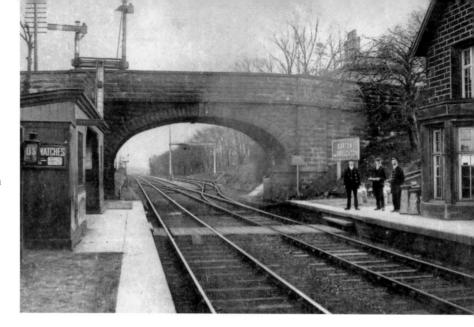

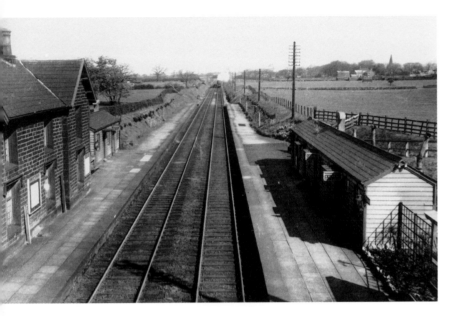

Right: Brock

From Barton and Broughton, the railway heads due north to the site of
Brock station, a little over two miles further on. Like Barton and Broughton,
this wayside station had a somewhat confusing early history, having been
opened in or around 1849 as a replacement for an earlier stopping place
known as Roebuck, which had been opened with the line in June 1840. The
replacement station was sited a short distance to the north of its predecessor.

Opposite: Barton and Broughton

A detailed view of the main station building at Barton and Broughton during
the early years of the twentieth century. This two-storey structure was solidly
constructed of local stone, which weathered to a very dark, greenish-grey
colour. The projecting bay window that can be seen to the left was later
removed – perhaps because it presented a danger to the public, being very
close to the platform edge.

Left: Barton and Broughton

Another view of Barton and Broughton, looking northwards from the road
overbridge, probably around 1939. Examination of the photographs reveals
that a number of changes had taken place since the pre-Grouping period;
in particular, the up side station building had evidently been enlarged to
provide a waiting room and a ladies room, in addition to the gentlemen's
urinal. The 1938 Railway Clearing House *Handbook of Stations* indicates
that Barton and Broughton was able to deal with livestock, coal class traffic
and general merchandise, while the yard crane had a capacity of five tons.
Goods facilities survived here until May 1965.

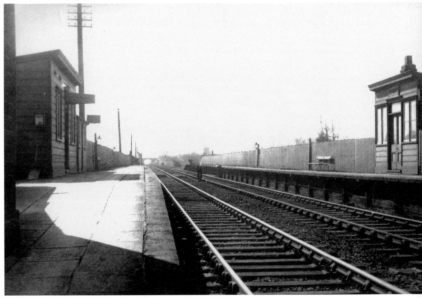

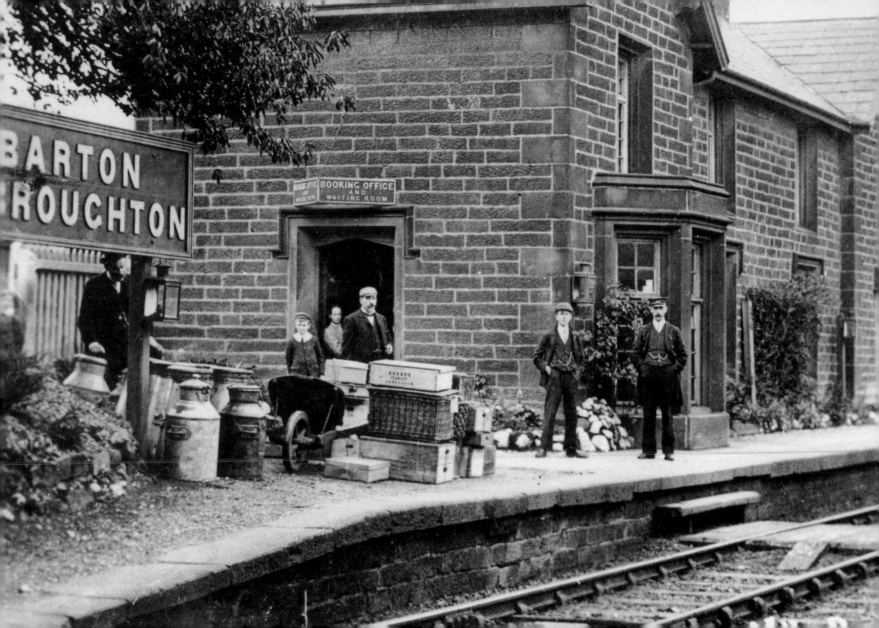

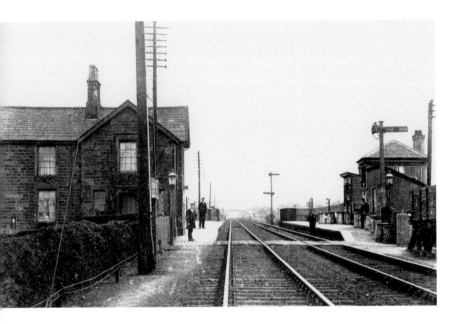

Right: Brock

A general view of Brock station during the early years of the twentieth century. The goods handling facilities provided here were of a rudimentary nature, although the station was able to deal with coal-class traffic and general merchandise.

Opposite: Brock

A detailed view showing the signal cabin and adjacent waiting shed, together with a small brick building that appears to have served as a goods lock-up. Brock station was closed in May 1939 as part of a cull of wayside stations on the Preston & Lancaster Junction Railway.

Left: Brock

An Edwardian postcard view of Brock station, showing the main station building, which was a two-storey, cottage-style structure incorporating domestic accommodation for the stationmaster and his family. Like other station buildings on the Lancaster and Preston Junction Railway, it was substantially built of local stone, with a low-pitched gable roof.

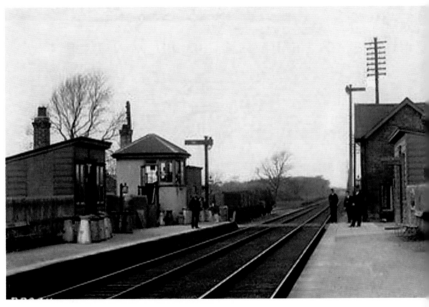

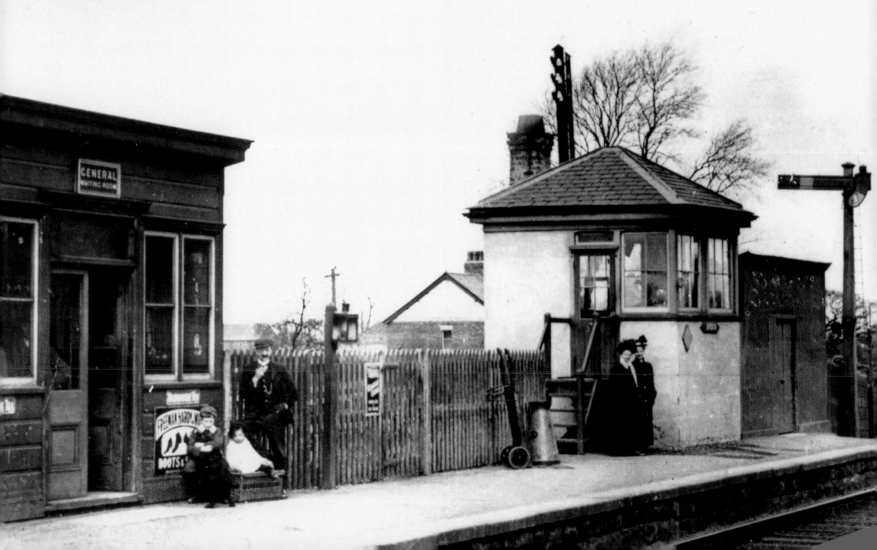

BROCK. LNWR

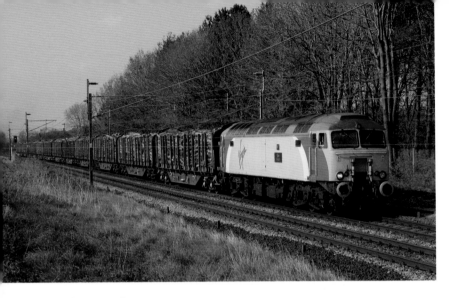

Left: Brock

Class 57 locomotive No. 57311 *Parker* passes Brock with the 1.27 p.m. Carlisle to Chirk timber train on 8 May 2008. The widespread use of diesel locomotives on an electrified main line has attracted much adverse criticism from environmentalists – the practice having become much more prevalent since the privatisation and fragmentation of BR. It is cheaper for the privatised train operators to employ diesel traction on services which start or terminate beyond the confines of the electrified system, and this has resulted in a situation whereby at least 50 per cent of the train services on the West Coast Main Line between Preston and Carlisle are now worked by diesel locomotives.

Right: Brock

Direct Rail Services Class 20 locomotives Nos 20302, 20306, 20310 and 20307 pass Brock with the 3.38 p.m. Sellafield to Crewe nuclear flask train on 6 May 2008. The use of four locomotives on this train is not as extravagant as it may look, as the train splits into two portions at Crewe, in order to serve individual power stations. Direct Rail Services, or DRS, was formed by British Nuclear Fuels in 1995, using five second-hand Class 20 locomotives. The operation has been greatly-expanded since that time, and DRS now operates a variety of locomotive types, including Class 37s, Class 47s and recently-introduced Class 68s. The business – now owned by the Nuclear Decommissioning Authority – employs around 400 staff, and has an annual turnover of over £75 million.

Opposite: Brock

Direct Rail Services Class 37 locomotives Nos 37218 and 37602 pass Bilsborrow, near the site of Brock station, with the 3.35 p.m. Sellafield to Crewe nuclear flask train on 12 April 2004. It is interesting to note that, as a subsidiary of the Nuclear Decommissioning Authority, DRS has remained a publicly-owned undertaking, despite the privatisation of the British railway system.

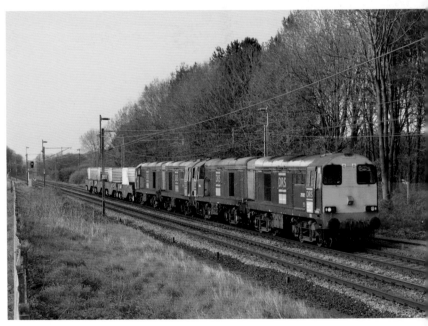

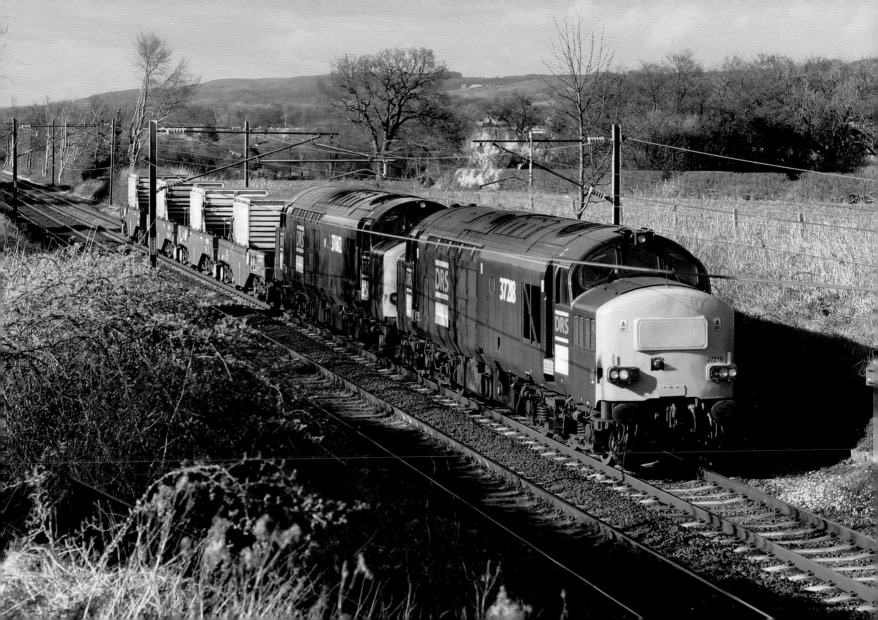

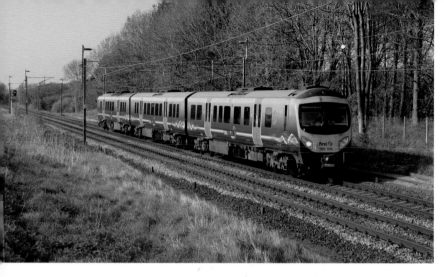

Left: Brock

Class 185 diesel unit No. 185106 passes Brock on 6 May 2008 with the 4.21 p.m. Barrow-in-Furness to Manchester Airport TransPennine service – a train that does not actually cross the Pennines at all! Although this appears, at first glance, to be a pleasant rural spot within sight of the distant Pennines, it is in fact an incredibly noisy location, as the M6 motorway, which is hidden behind the trees on the right, runs parallel to the railway for several miles to the north of Preston

Right: Brock

Class 325 electric mail unit No. 325012 leads two unidentified classmates past Brock with the 1.34 p.m. Shieldmuir to Warrington Royal Mail service on 6 May 2008. The competing mode of transport, the M6 motorway, is just behind the trees on the right. Just a few years previously it had appeared that all mail traffic had been lost, but there has, in recent years, been a modest revival. Until 2010 the remaining Royal Mail contract workings were worked over the West Coast Main Line by First GBRf, using sixteen Class 325 units. These sets were transferred to DB Schenker – a subsidiary of the Deutsche Bahn – in the summer of 2010.

Opposite: Brock – Class 86 Locomotives

Following electrification of the Preston to Glasgow line in May 1974, the best London to Glasgow services were hauled throughout by Class 86 or Class 87 electric locomotives. These engines have now been replaced on long-distance passenger workings by Class 390 Pendolino units, but electric locomotives continue to appear on freight workings. This recent view shows Class 86 locomotives Nos. 86607 and 86610 passing Brock while hauling the 1.00 p.m. Coatbridge to Crewe Freightliner service on 6 May 2008. It seems a little strange to see a pair of 4,040 hp electric locomotives hauling Freightliner trains, while on other routes a single 3,200 hp Class 66 diesel locomotive handles a similar length train.

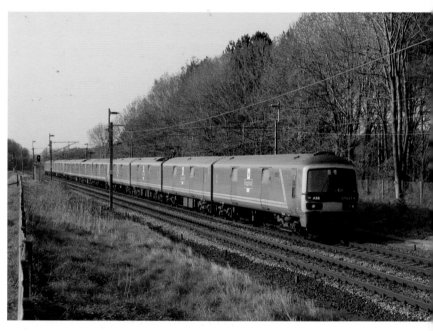

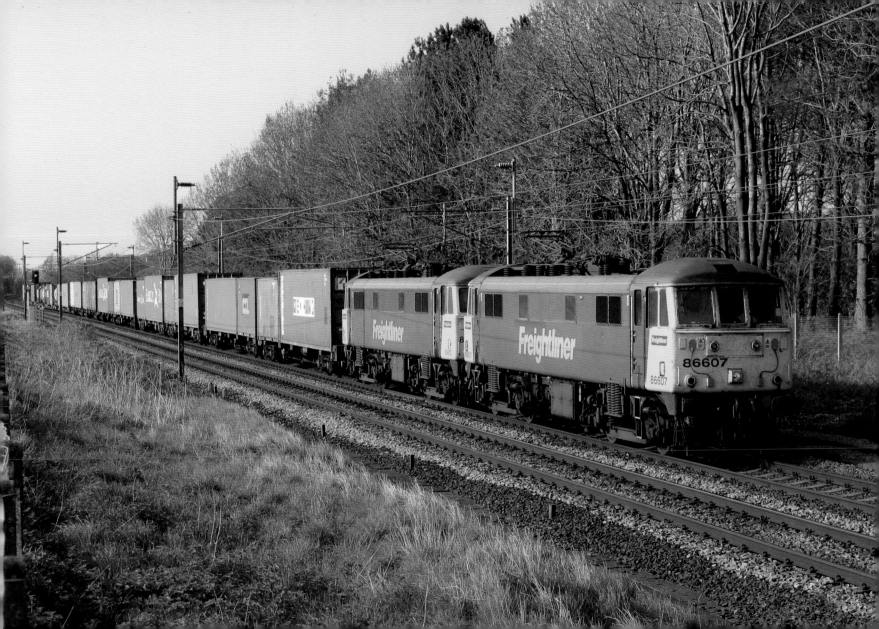

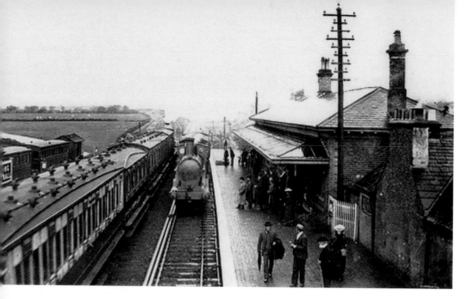

Garstang and Catterall

Maintaining its northerly heading, the line continues along virtually dead-level alignments to Garstang and Catterall (218.5 miles). This now-closed stopping place was opened on 25 June 1840, and it became a junction in 1870, when the first section of the Garstang & Knott End Railway was brought into use. The station was situated on an embankment with an underbridge immediately to the south, while the station building, on the up side, was a split-level structure with the station master's house at platform level and the bedrooms below. Three platforms were available, the down side being an island with an outer face for Knott End traffic on the west side.

Facilities on the down platform comprised a timber waiting room, together with a ramshackle wooden hut that had originally functioned as the Garstang and Knott End booking office. The up and down platforms were connected by a lattice girder footbridge, access to the up platform being via a sloping pathway. The layout at Garstang and Catterall was relatively complex. The goods yard, on the down side, incorporated a lengthy reception loop that was linked to the up and down running lines by trailing connections. A number of sidings diverged from the loop, one of these being the goods shed road, while others were used for coal or other wagon load traffic. The Knott End line extended northwards from the goods loop and, having passed behind the down side island platform, it continued alongside the LNWR main line for a considerable distance before turn west towards Garstang Town station. The signal cabin was sited to the south of the station on the up side.

These Edwardian postcards show Garstang and Catterall around 1912; the upper view is looking northwards from the footbridge, and the lower view shows a Knott End train in the branch platform, the locomotive being *Farmer's Friend*, a Hudswell Clarke 0-6-0ST.

Opposite: Garstang and Catterall

This Edwardian postcard scene shows Garstang and Catterall around 1912; the photograph is looking westwards from the forecourt of the neighbouring Kenlis Arms hotel.

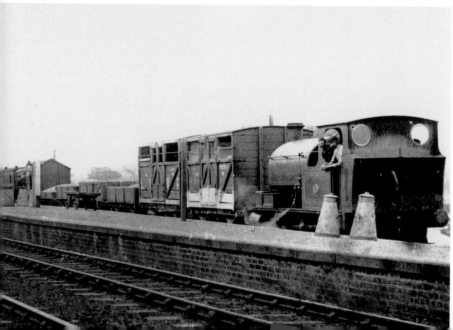

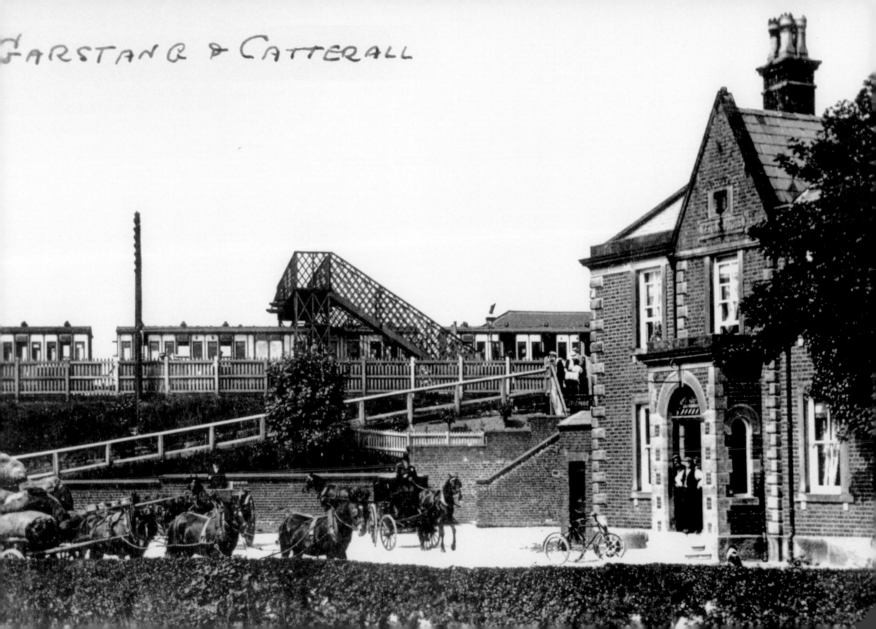

GARSTANG & CATTERALL

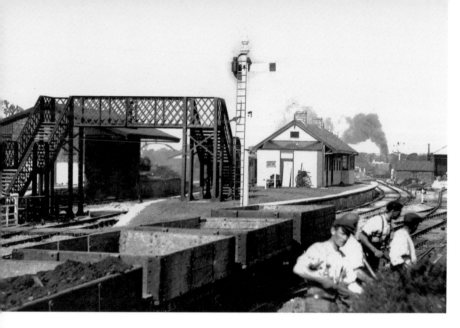

Garstang and Catterall – The Knott End Railway

The Garstang & Knott End Railway was sanctioned by Parliament on 30 June 1864, but the promoters experienced financial difficulties following the failure of bankers Overend, Gurney, & Co. in May 1866, and the first section from Garstang to Stakepool (Pilling), a distance of seven miles, was not opened until Monday 5 December 1870. A ceremonial Opening Day was held on Wednesday 14 December, the event being marked by the running of a special train, which conveyed the directors and shareholders over the new line, together with members of the Scorton Brass Band, who played at intervals along the route. The proprietors of the Garstang and Knott End line were determined to work their own train services, but the financial position of the company was precarious, and the railway ceased operations in 1872. At length, a receiver was appointed on behalf of the debenture holders, and the G&KER was re-opened for goods traffic on 23 February 1875, and for the carriage of passenger on 17 April 1875.

At the end of the Victorian period, a new undertaking known as The Knott End Railway was formed to take over the railway from the original company. In the short term, this strategy was relatively successful, and on 29 July 1908 the line was finally completed throughout to its intended terminus at Knott End. Here, the railway ended in a substantially built station with ample accommodation for day trippers and seaside holidaymakers. More importantly, there was also a connection to Preesall Saltworks, which generated additional freight traffic. The completed K&KER was 11.25 miles in length and single track throughout, while the steepest gradients were at 1 in 73 and 1 in 89.

The upper picture shows Garstang Town station, the operational headquarters of the G&KER, which was two miles from Garstang and Catterall. This small station incorporated locomotive and carriage sheds in addition to the usual good yard and passenger facilities. The platform was arranged as an island with tracks on each side, public access being by means of a footbridge. The station building was a single-storey structure with a low-pitched gable roof and two squat chimney stacks. The lower view shows Hudswell Clarke 0-6-0ST *Jubilee Queen* (Works No. 484) at Garstang.

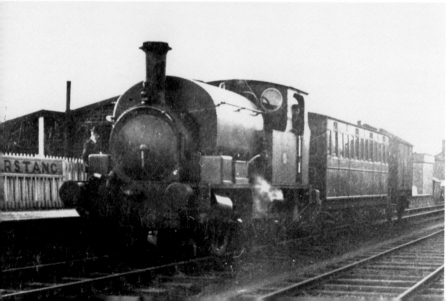

Garstang and Catterall – The Knott End Line

Right: The Knott End line was worked by a number of small tank locomotives, including Manning Wardle 2-6-0T *Blackpool* (works No. 1747), which is seen at Garstang Town around 1910. This locomotive was built in 1909; there were, by that time, four locomotives on the Garstang & Knott End Railway, all of which survived long enough to be taken over by the London Midland & Scottish Railway in 1923.

Below left: Manning Wardle 0-6-0T *Knott End* (Works No. 1732) at Knott End with an up train around 1908. In 10 December 1870 The *Preston Guardian* reported that the G&KER carriages were built on 'the American principle', and the passengers found them to be 'particularly comfortable'. The Garstang and Knott End engine livery was dark red, lined in yellow or white.

Below right: Knott End station on 15 September 1908, with LNWR 0-6-0ST No. 3210 standing against the terminal buffer stops. When first opened the railway was served by three trains each way between Garstang and Catterall and Pilling, with additional short-distance workings between Garstang and Catterall and Garstang Town.

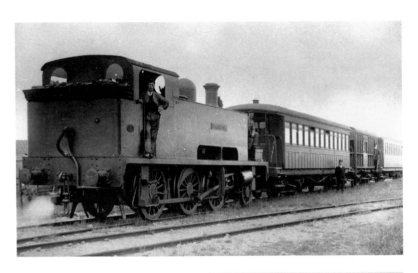

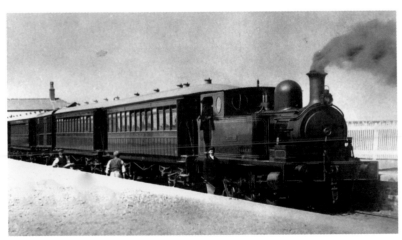

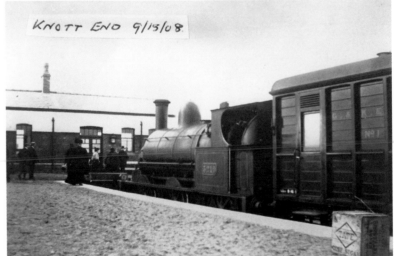

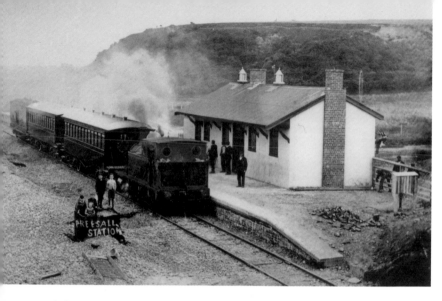

Left: Garstang and Catterall – The Knott End Line

This final view of the G&KER shows Manning Wardle 0-6-0T *Knott End* at the intermediate station of Preesall with a 3-coach train around 1908. The Garstang & Knott End Railway lost its separate identity in 1923, when it became part of the newly-created London Midland & Scottish Railway under the provisions of the Railways Act 1921. Unfortunately, the Knott End branch was soon suffering from bus competition, and in view of this the LMS withdrew passenger services with effect from 31 March 1930. As this was a Monday, the final trains ran on Saturday 29 March, on which day large numbers of people turned out to travel on the railway for the last time. This withdrawal did not entail complete closure of the line, however, and freight traffic continued for many years. The line was closed beyond Pilling in 1950, while in 1963 the route was cut back to Garstang Town. The remaining portion of the G&KER line was finally closed to all traffic in August 1965, and the only part of the Garstang & Knott End Railway then remaining was the down running loop at Garstang and Catterall.

Right: Garstang and Catterall

Class 156 unit No. 156452 is pictured near the site of Garstang and Catterall station with the 4.58 p.m. Barrow-in-Furness to Manchester Airport First North Western service on 16 May 2002. This is a comparatively rare view showing the modified Provincial Railways livery that was applied to the small fleet of class '156' units that were refurbished by North West Regional Railways in the late 1990s. Introduced in 1987, these two-car 'second generation' diesel sets were built in Birmingham by Metropolitan-Cammell, and they can seat 150 standard class passengers.

Opposite: Garstang and Catterall – The Final Closure

The main line station at Garstang and Catterall continued to serve as a useful railhead for the surrounding area until Monday 15 October 1967, when passenger services were withdrawn. Freight facilities survived for another fourteen months but finally, in January 1969, this Lancashire station was closed to all traffic. The accompanying photograph, taken in the final years of operation, is looking south towards London Euston, with the main, upside station building to the left and the signal box in the distance.

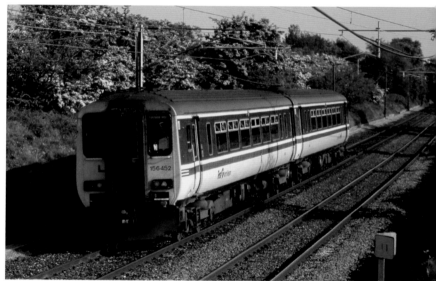

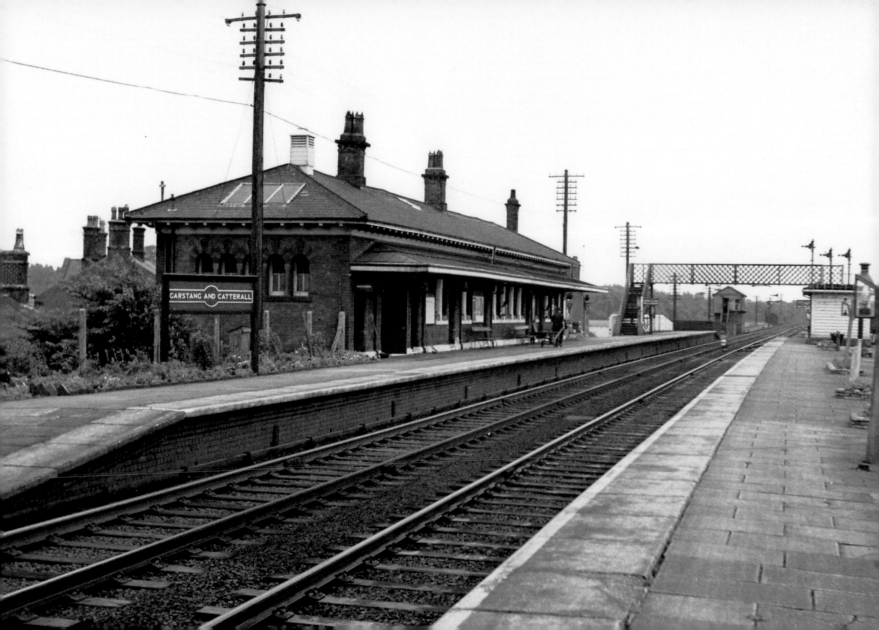

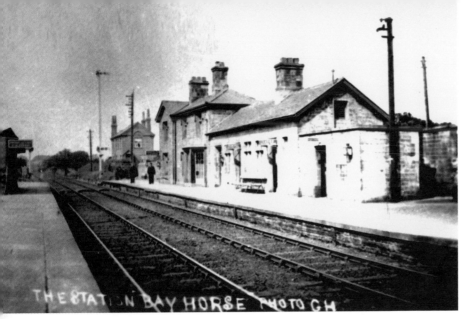

THE STATION BAY HORSE PHOTO CH

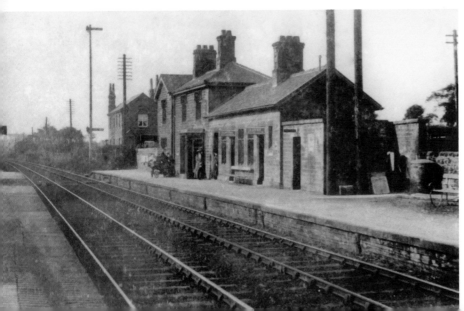

Bay Horse

Hurrying northwards along level alignments, trains rush past the closed stations at Scorton and Bay Horse, both of which were opened by the Lancaster and Preston Junction Railway on 25 June 1840. Scorton was closed in 1939, but Bay Horse (224.5 miles) survived until the British Railways period, and was closed with effect from 13 June 1960. The photographs provide a general view of Bay Horse station during the early years of the twentieth century; the station derived its name from that of a nearby inn.

Bay Horse was the setting for an accident that took place on 12 August 1848. At that time the Lancaster Canal Co. worked local trains between Preston and Lancaster Penny Street, whereas the Lancaster & Carlisle Railway provided non-stop main line services. Unfortunately, these two undertakings were in dispute with each other, and for this reason nobody was quite sure who was responsible for operating the line. The chaotic arrangements between Preston and Lancaster resulted, perhaps inevitably, in an accident that took place at Bay Horse station on 21 August 1848. On that fateful day, the 9.00 a.m. express from Euston to Glasgow, which should have left Preston at 3.10 p.m., departed at 4.24 p.m. and ran into the rear of the 3.45 p.m. local train to Lancaster with such force than one passenger was killed and several others were injured.

Opposite: **Bay Horse**
A view of Bay Horse station during the British Railways period.

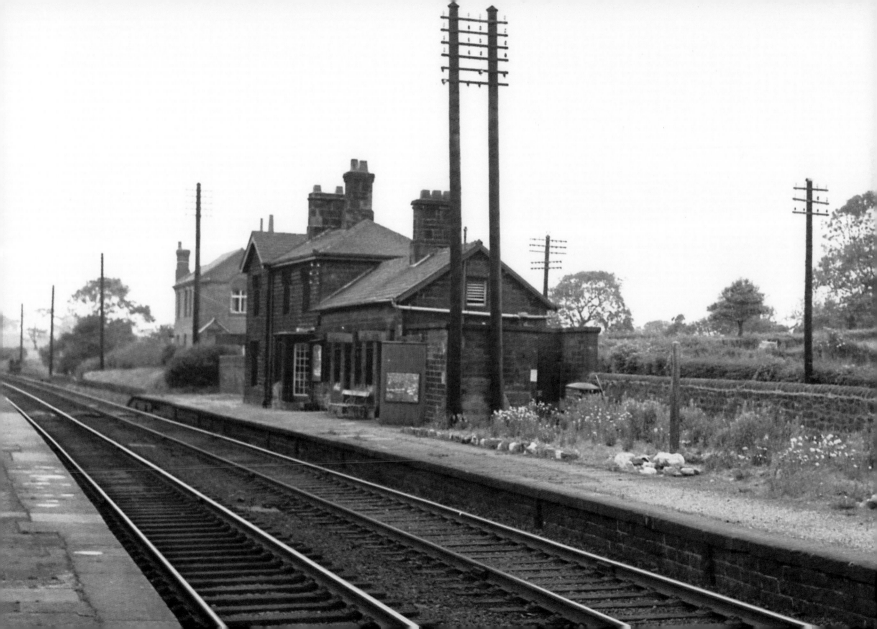

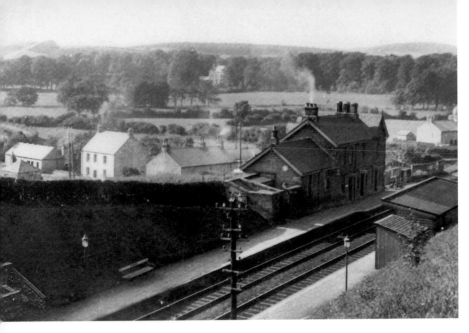

Galgate

The abandoned station at Galgate, to the south of Lancaster, was another victim of the 1939 closures. Opened on 25 June 1840, this wayside stopping place served a small village that had grown up to house workers from the nearby Galgate Silk Mill. The mill, which was on the east side of the village, dated from 1792, although the tall, red brick mill building which dominated the village was of somewhat later construction, having been built in 1851. The station was situated on the edge of the village, a short distance to the south of Galgate viaduct. The latter structure has six stone arches, and it carries the railway at roof-top height from north-to-south above the village.

The station building, on the down side, was a two-storey structure that incorporated living accommodation for the station master and his family; it was built of stone, with a low-pitched gable roof. The up and down sides of the station were linked by a barrow crossing, and the signal box was sited at the north end of the down platform. Facilities on the up platform consisted of a simple, timber-framed waiting shed. There were no goods sidings or loading docks – Galgate being a passenger-only station. The upper picture, dating from around 1912, is looking north-westwards from an elevated position above the up platform, while the lower view looks northwards along the down platform.

Opposite: Galgate

A detailed study of the main station building during the early years of the twentieth century. This two-storey structure contained the usual booking office and waiting room, together with domestic accommodation for station masters such as Jess Peck, who lived here for many years with his wife Florence and their children.

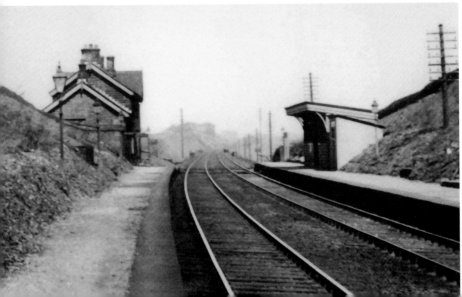

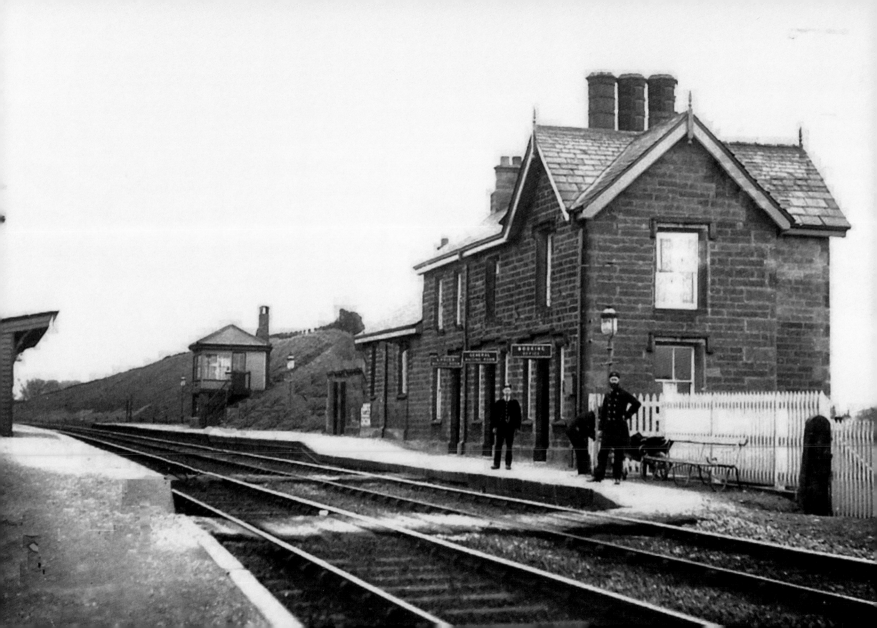

Oubeck Signal Box and Loops

Having rushed past the site of Galgate's long-closed station, down trains traverse a huge embankment with good views, to the right, of the distant Pennines. To the left, in contrast, the scene is entirely pastoral, with white-washed cottages and farmsteads nestling picturesquely among the gently rolling hills – the lush, green landscape being reminiscent of Ireland or Cornwall.

With a minor road running parallel to the west and the busy A6 maintaining a similar course on the east side of the line, down trains cross a small stream on a single-span stone arched bridge. Oubeck signal box and goods loops were immediately beyond. Although there was never a station at Oubeck, the up and down running loops provided here have always been of some importance – particularly so in steam days, when scores of slow-moving freight trains had to be shunted clear of the Anglo-Scottish expresses and other important workings.

The upper view shows an unidentified Class 47 locomotive at Oubeck around 1974, while the lower view shows sister engine No. D1576 standing in the up loop with an engineer's train.

Opposite: Oubeck Signal Box and Loops

A panoramic view of Oubeck Loops, looking north towards Lancaster on a bright and sunny day in October 1971. A freight train is passing through on the down main line, while the yellow brick buildings of the University of Lancaster at Bailrigg can be discerned in the distance.

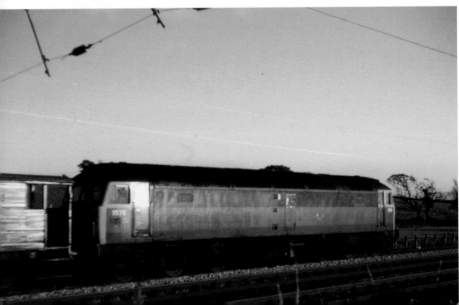

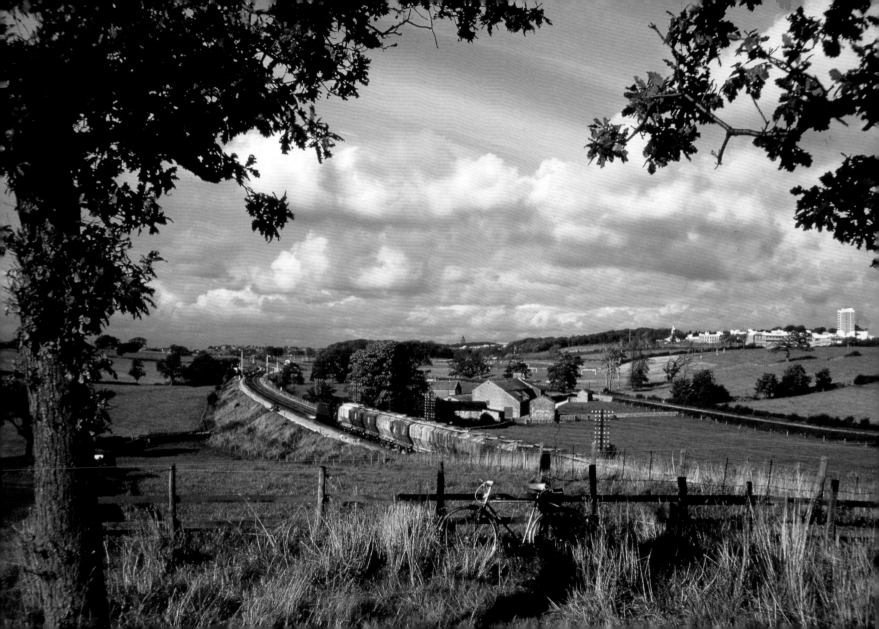

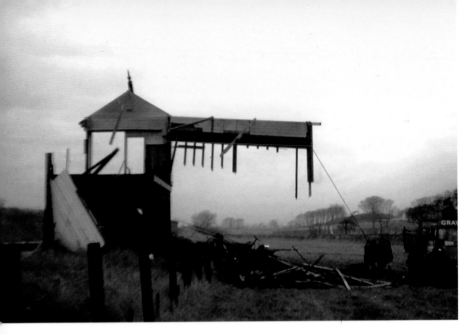

Oubeck Signal Box and Loops

Until the 1970s, Oubeck loops were controlled from a standard LNWR gable-roofed signal box on the up side of the line. The box was two miles seventy-six chains north of Bay Horse Box and just one mile sixty-one chains to the south of the next block post at Lancaster old junction. Oubeck Box was a typical LNWR design, with a brick locking room and a timber upper storey. Like most north western signal boxes built during Victorian period, the gable roof was virtually flush with the end walls – giving rise to a distinctly 'slab-sided' appearance. The box was demolished on 24 January 1973, the timber-framed upper floor being pulled down with the aid of ropes after the roof had been removed, as shown in these two photographs.

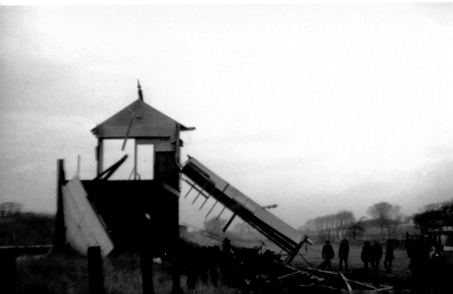

Lancaster Castle Station – The Southern Approaches

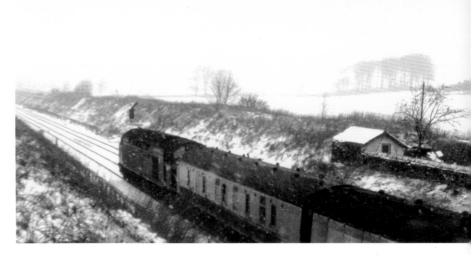

From Oubeck Loops, trains pass beneath a single-span stone arched bridge and then sweep northwards through a long, straight cutting. Travellers can, by glancing to the right before their trains enter the cutting, catch a fleeting glimpse of the University of Lancaster, which obtained its Charter on 14 September 1964, and moved to its present site two years later. It was, at that time, suggested that a new station might be constructed at Oubeck to serve the new university, but sadly, this idea was never implemented. Emerging from the cutting, the line passes beneath another single-span overbridge and continues towards Lancaster through a pleasant, tree-dotted landscape.

The photographs depict diesel-hauled trains in Oubeck cutting; the upper view, taken during a snow storm on 14 January 1973, shows a northbound passenger working, while the lower picture provides a glimpse of Class 40 locomotive No. D213 *Andania* hauling an engineering train during electrification work on 13 May 1973.

Entering the outlying district of Scotforth, the line reaches a further cutting which is spanned by three more bridges. One of these carries a road, while the other two carry minor lanes across the railway. One of the latter bridges is, unusually, divided into two by an intermediate wall between its main parapets, and by this means, it carries both a public right-of-way and a private farm track across the line; the bridge is known locally as the Double Bridge.

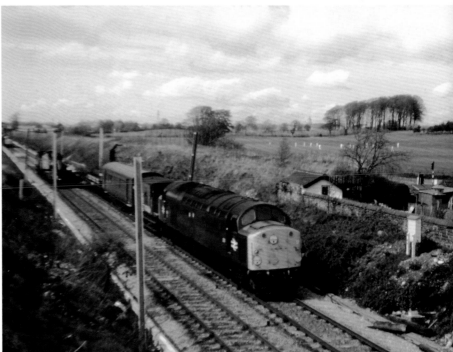

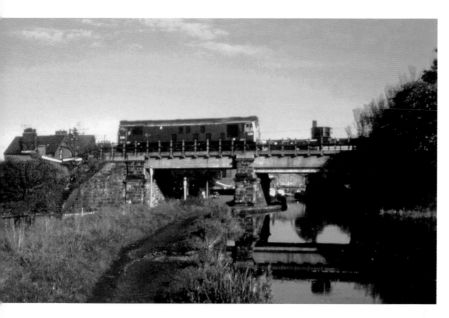

Right: Lancaster Castle Station

Having crossed the Lancaster Canal, trains approach Lancaster
Castle station in a northerly direction, the station being aligned from
north-to-south, with its main buildings on the up side. Situated some
230 miles from London Euston, the station was opened by the Lancaster &
Carlisle Railway on 22 September 1846, and its original buildings were
designed by the eminent Victorian architect Sir William Tite in the
Tudor-gothic style. When first opened, the station had incorporated just
two platforms for up and down traffic, although north-facing bays were
added at a relatively early date. This first station was by-passed by two
goods lines, which ran behind the up platform on the east side of the
running lines. Castle Station is well-sited in relation to the town (which
became a city in 1937), and travellers arriving in Lancaster by train could
reach the main shopping and commercial areas after a few minutes walk.
The illustration depicts the down side station building in 1846.

Left: Lancaster Old Junction

Now running through an urban area, the line continues northwards to the
site of Lancaster old junction. Here, the present-day route curves sharply
north-westwards, while an abandoned branch continues northwards to the
site of the original Lancaster and Preston Junction Railway terminus at
Penny Street. This junction was once controlled from Lancaster old junction
signal box, which was also known as Lancaster No. 1 Box. The former
Penny Street station building later found a new role as a nurses' hostel
attached to the neighbouring Lancaster Royal Infirmary, while the branch
from Lancaster old junction remained in situ for many years – a goods
shed and other relics of the L&PJ railway being intact as late as the 1970s.
Curving onto the former Lancaster and Carlisle section, trains pass beneath
the Ashton Road Bridge and run through a further cutting that is soon
replaced by embankments as the line approaches the Lancaster Canal, which
was crossed by means of a twin-span girder bridge with stone abutments as
shown in this 1971 photograph.

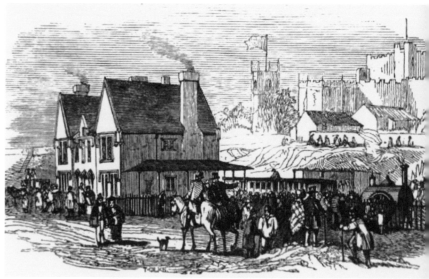

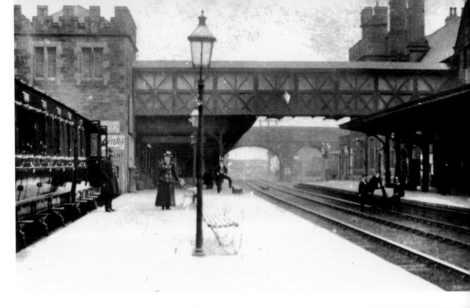

Lancaster Castle Station

A programme of improvements which was carried out at the end of nineteenth century and completed by 1902, resulted in the provision of a much improved track layout, with up and down fast lines between the main platforms. The original down platform on the west side was retained, but the old southbound platform was replaced by a new up platform with extensive waiting rooms and other facilities. Two further platforms were inserted between the new up platform and the retaining wall which flanked the eastern side of the railway – the resulting station having four through platforms in all.

The four main platforms are linked by a fully-enclosed footbridge which extends horizontally from a separate high-level booking hall, and there are two terminal bays at the north end of the main down platform which were originally used by LNWR branch services to Glasson Dock and Morecambe (Euston Road). The whole station is overshadowed by Lancaster's brooding, heavily-machicolated medieval castle, which can be seen on the east side of the railway.

The upper view shows the old up platform and the original double-track layout, probably during the 1890s, while the colour photograph was taken from a similar vantage point on 7 May 1974 – the train that can be seen standing alongside the down platform being a royal special carrying Elizabeth II, who was about to open the Preston to Carlisle electrification scheme.

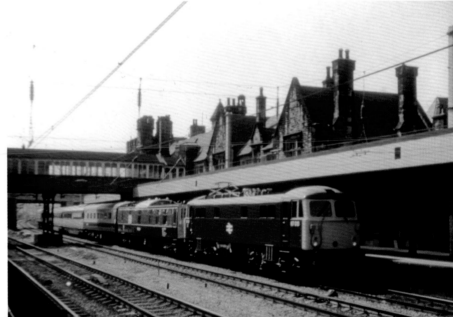

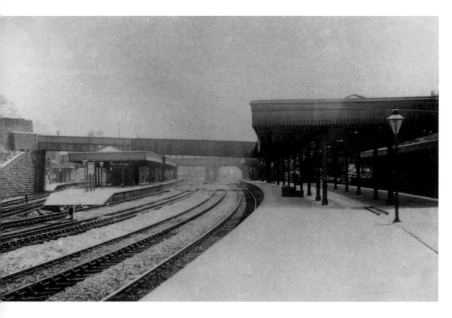

Right: Lancaster Castle – The Down Side Station Building

It is hard to distinguish the new LNWR buildings from the older parts of the station because the new booking offices and waiting rooms were built in a matching architectural style. A substantial fragment of Sir William Tite's original station building can nevertheless be seen on the down side, this two-storey Tudor-gothic structure being shown in the accompanying photograph. The remodelled station was signalled from four standard LNWR brick and timber signal boxes, which were designated Lancaster No. 1, No. 2, No. 3 and No. 4 boxes. Lancaster No. 4 box which was situated on the down side of the line at the north end of the station, was a towering, three-storey cabin with a 144-lever frame.

Left: Lancaster Castle Station

A general view of Lancaster Castle station, looking south towards London Euston shortly after the completion of the rebuilding scheme. Platform 3, the main down platform, occupies the centre of the picture, and Platform 4, which is still the main up platform, can be seen to the left. Platforms 1 and 2, can be glimpsed to the right, while Platforms 5 and 6, the two easternmost platforms – which were electrified in connection with the Midland Railway's experimental Lancaster and Morecambe electric system in 1908 – are visible on the extreme left of the picture. The 1902 reconstruction entailed some major bridge works, which were necessary because Castle station was spanned by two road bridges – Meeting House Lane being carried across the line at the south end of the station, while Castle Park Road crosses the platforms at the north end of the station buildings.

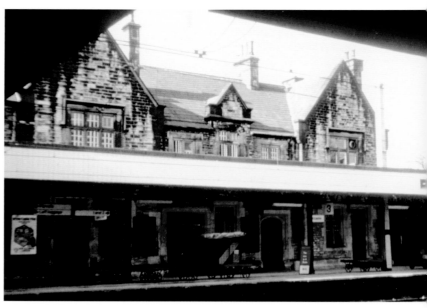

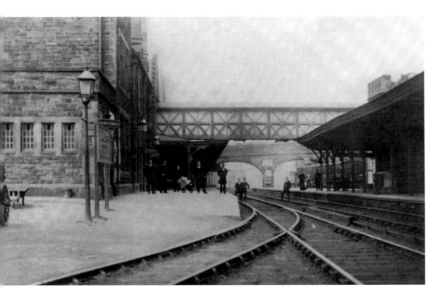

Right: Lancaster Castle Station

Looking northwards along the main down platform at Lancaster Castle around 1912. The plate girder bridge that can be seen in the background carries Castle Park Road across the railway – Castle Park Road was the site of a small stable yard that had once provided accommodation for railway shunting and dray horses. The station seems to have been known as Lancaster Castle from an early date, while the 'Little' North Western station was dubbed Lancaster Green Ayre to prevent confusion between the two stations.

Left: Lancaster Castle Station

A view of the down platform prior to the reconstruction of the station. The siding that can be seen in the foreground gave access to a goods yard. In steam days, Lancaster Castle had incorporated a number of goods-handling facilities, including a goods shed and associated sidings that were sited alongside the main line on the down side. There were additional sidings on the up side of the line, while further goods sidings were available in the former Penny Street station, which could be reached by means of a reverse shunt from Lancaster old junction. Penny Street sidings were still used by goods trains in the early LMS period, and the 1923 working timetable reveals that several trip workings and light engine movements took place at that time between Lancaster Quay Sidings, Lancaster Castle, and Lancaster old station. In later years Penny Street sidings were used primarily for storage purposes.

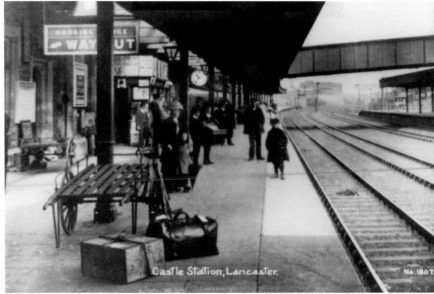

Castle Station, Lancaster. No.1807

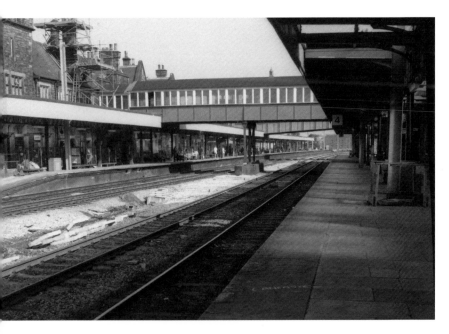

Right: Lancaster Castle Station

This early 1970s view is looking southwards along Platform 3. In early BR days it became the practice to run the principal Anglo–Scottish expresses as limited stop workings that called only at Crewe, Carlisle or other more important intermediate stations. Lancaster was a regular stop for Barrow to Euston services and other second-rank main line trains such as those that ran between Liverpool and Glasgow. In more recent years the number of Anglo-Scottish services calling at Lancaster has progressively increased, and at the time of writing all of the most important workings call at the station, Platform 3 being the main northbound platform for these long-distance InterCity services, which are now worked by tilting Pendolino trains.

Left: Lancaster Castle Station

A further view of Lancaster Castle station, looking northwards along Platform 4, around 1973. Electrification work is evidently in progress – rectangular holes having been cut into the platform canopies to facilitate the installation of the overhead catenary. The original Lancaster and Carlisle passenger timetable had provided no more than two trains each way, together with one or two short distance workings at the southern end of the line between Lancaster and Kendal. From these humble beginnings, the service increased progressively until by the early 1900s Lancaster Castle was handling approximately a hundred main line arrivals and departures each day. In addition, there was extensive freight traffic, plus around twenty trains each way between Lancaster and Morecambe.

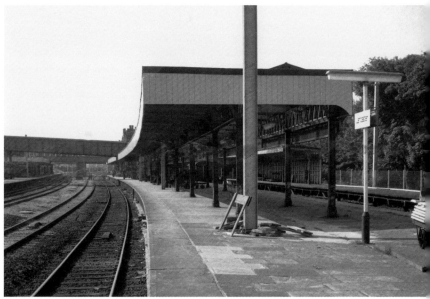

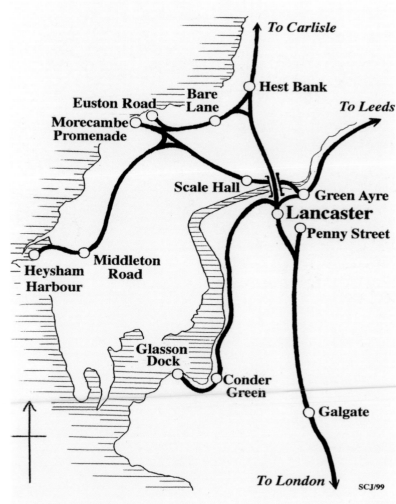

Lancaster Castle Station

Above: A detailed view of terminal Platforms 1 and 2, which are now used by local services to Morecambe, Leeds and Barrow-in-Furness.

Right: A sketch map showing the railway system in and around Lancaster at its fullest extent. The West Coast Main Line runs from north-to-south, while the Midland route from Lancaster Green Ayre to Morecambe Promenade and Heysham follows an approximate east-to-west alignment. The LNWR branch to Morecambe runs westwards from Hest Bank to its terminus at Euston Road, and the Glasson Dock branch follows the River Lune towards its destination. The Glasson Dock branch and the Midland route to Morecambe have now been closed, but trains still run to and from Morecambe and Heysham Harbour, Morecambe being reached via the former LNWR branch, which is linked to the main line by means of a triangular junction at Hest Bank.

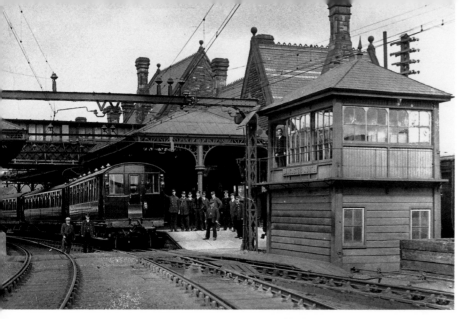

The Lancaster, Morecambe and Heysham Electrification Scheme

Opened on 12 June 1848, the Midland station at Lancaster Green Ayre was a picturesque, riverside station with three platforms and attractive Tudor-gothic buildings. The up and down platforms were linked by a covered footbridge, while for railway enthusiasts Green Ayre was of particular interest, in that it was the site of a motive power depot, which normally had an allocation of around forty locomotives. The shed was built on a restricted site between Cable Street and the River Lune, and for this reason it was arranged as a semi-roundhouse with seven dead-end roads radiating from a 60 foot turntable. The Midland shed at Green Ayre eventually became Lancaster's main shed – although a much smaller former LNWR engine shed at Lancaster old junction did not lose its allocation until the LMS period, when the shunting engines that it had formerly housed were transferred to Green Ayre.

The Midland lines from Lancaster Green Ayre to Morecambe and Heysham were electrified on the 6,600 volt AC overhead system in 1908, the overhead wires being extended from Lancaster Green Ayre to the LNWR station at Lancaster Castle, so that the electric trains could run between Lancaster Castle and Heysham Harbour, with intermediate reversals at Green Ayre and Morecambe Promenade. The new service was worked by three 60-feet motor coaches seating seventy-two passengers, together with four 43-feet trailers with seats for a further fifty-six travellers. These vehicles ran in conjunction with ordinary coaches, which had been adapted to work with the electric stock. The normal service between Lancaster and Morecambe provided up to twenty-six workings each way, with about ten services running to or from Heysham harbour.

The photographs show Midland electric trains at Green Ayre station, the upper view having been taken around 1909, whereas the lower view dates from the 1930s – by which time the characteristic Midland signal cabin had been replaced by a new LMS cabin (which can be seen in the background). These pioneer high-voltage electric multiple units were equipped with curious 'trumpet horns' that had been provided by Messrs Boosey & Co., the famous music firm.

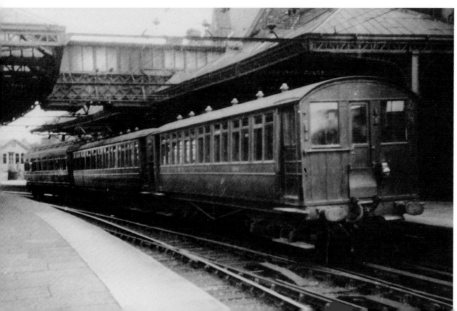

Lancaster, Morecambe & Heysham Electrification Scheme

The original Midland units worked on the Lancaster to Morecambe line for over forty years, but they had reached the end of their useful life by the BR period, and in 1951 they were replaced by push-pull trains worked by Stanier Class 2P 0-4-4Ts Nos 41900, 41902, 41902, 41903 and 41904 and one motor-fitted 0-6-0 tank locomotive. It had, in the meantime, been decided that the line would be used as a testing ground for electrification using alternating current at the industrial frequency of fifty cycles, and in August 1953 electric operation resumed, using an experimental 6,600 volts AC fifty cycle overhead system.

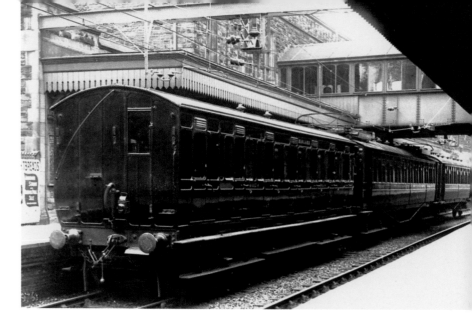

The revived service was worked by reconditioned LNWR three-car electric units. These former LNWR sets, which dated from 1914 and had been stored out of use since 1940, were hardly new, but they were popular locally – the general opinion being that they were far more comfortable than the earlier Midland vehicles (which had slatted wooden seats). Perhaps more importantly, technical information obtained from the use of these venerable units led to the adoption of 25kV 50 cycle AC electrification on the West Coast Main Line. Sadly, these interesting electric units were all withdrawn on Saturday 1 January 1966, the last train being the 11.10 p.m. Morecambe Promenade to Lancaster service, which carried a special headboard and a wreath to mark the occasion.

The upper picture shows one of the former Midland three-car sets at Lancaster Castle station, the vehicle on the left being an ordinary Midland full-third that has been adapted to run with the electric motor coaches. The final view shows a two-car unit at Lancaster Green Ayre, probably during the mid-1930s.

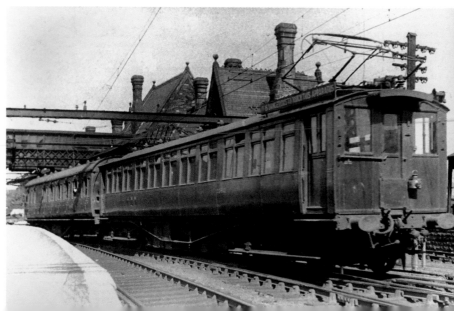

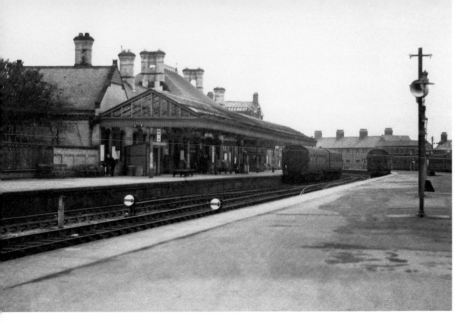

Lancaster – The Euston Road Branch

As we have seen, the Morecambe Bay Harbour & Railway was opened on 12 June 1848, and the provision of a rail link between Morecambe and the populous industrial areas of West Yorkshire ensured that Morecambe was able to develop as a residential centre for prosperous businessmen and professional people who could afford to live at a distance from the reeking mill chimneys of Leeds or Bradford while travelling daily to work in comfortable residential expresses. The hitherto unimportant seaside village of Poulton was thereby transformed into a thriving watering place – although holiday traffic was not particularly significant during the 1850s and 1860s, and Morecambe was primarily a residential town in the early Victorian period. It was also a working port, and its harbour facilities were important enough for the LNWR to build a short branch to Morecambe from the West Coast Main Line at Hest Bank. The LNWR branch was authorised by the Lancaster & Carlisle Railway General Powers Act of 13 August 1859, and opened on 8 August 1864. At first all trains used the Midland station, but on 10 May 1886 the LNWR opened its own terminus at Morecambe Euston Road.

The North Western station, shown in the upper picture, was equipped with ornate, yellow brick buildings, and it was linked to the nearby Midland route by a short connecting line that had formerly been used by all LNWR trains on their way to and from the Midland station. Euston Road station was closed to regular traffic in 1958, but excursion trains continued to use the station until 1962. Thereafter, all trains used the neighbouring Midland station. The lower view shows the still-extant station at Bare Lane, which was opened in 1864 and is the only intermediate station on the Morecambe branch. Up and down platforms are provided here, with picturesque station buildings on the up side. A signal box was sited on the opposite platform, and this controlled the adjacent level crossing.

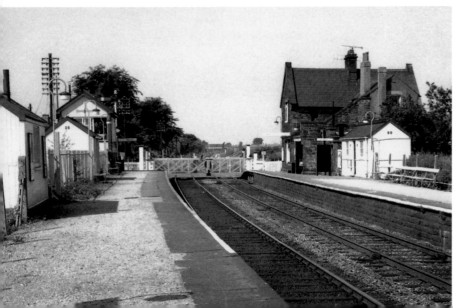

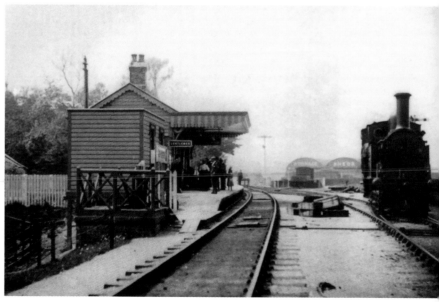

Left: Lancaster – The Glasson Dock Line

On 22 July 1878 the LNWR obtained Parliamentary consent for a five mile sixteen chain branch from Lancaster Castle station to Glasson Dock. Construction began in the summer of 1879, but subsequent progress was slower than anticipated and the line was not opened until Monday 9 July 1883. The completed railway curved away from the main line near Lancaster No. 4 signal box and, for much of its length, the new line followed the east bank of the River Lune, with a consequent need for embanking and flood control culverts. There was an intermediate station at Conder Green, together with a private halt at Ashton Park for the benefit of Lord Ashton, while quayside sidings were provided at Lancaster and at Glasson Dock. Journeys came to an end in a small station with a short platform on the down side and a run-round loop to the north. The station building was a timber structure containing the usual ticket office and waiting room, while the gentlemen's toilets occupied a projecting wing on the east side.

Right: Lancaster – The Glasson Dock Line

The layout at Glasson Dock was relatively simple. Three sidings extended westwards from the run-round loop, one of these being a short goods siding which terminated in a loading dock, while the other two were dockside lines. One of the dock lines extended alongside a tidal quay on the north side of the dock area, and the other served the inner and outer basins; these two dock lines converged at the north-western extremity of the dock complex, a wagon turntable being available to facilitate the movement of vehicles between the different parts of the dock complex. The inner basin dated from the 1820s, and it measured 900 feet by 1200 feet, while the outer 'wet dock' measured 500 feet by 200 feet. The photograph is looking west towards the dock area, with a LNWR tank locomotive standing on the run-round loop.

GLASSON DOCK BRANCH (Single Line).

	WEEK DAYS. DOWN TRAINS	1 Pas	2	3 C Goods	4 Pas	5 Motor SO	6 Motor S	7 Motor SO	8 Pas WSO	9 G Goods	10 Motor	11 Motor	12 Pas SO	13 Pas WSO
Miles		a.m.		a.m.	a.m.	a.m.	p.m.	p.m.	p.m.	p.m.	p.m.	p.m.	p.m.	p.m.
0	Lancasterdep	7 0	...	7 50	9 10	11 55	12 10	12 40	2 15	2 35	5 0	6 10	7 30	9 12
4⅛	Conder Green	7 12	9 22	12 7	12 22	...	2 27	...	5 12	6 22	7 42	9 12
4⅞	Glasson Dockarr	7 15	...	8 15	9 25	12 10	12 25	12 55	2 30 See note	3 0	5 15	6 25	7 45	9 15

	WEEK DAYS. UP TRAINS	14 Pas	15	16 Pas	17 Motor MO	18 Motor SO	19	20	21 Pas WSO	22 G Goods	23 Motor	24 Motor	25 Pas SO	25 Pas WSO
		a.m.		a.m.	a.m.	p.m.	p.m.	...	p.m.	p.m.	p.m.	p.m.	p.m.	p.m.
0	Glasson Dockdep	8 25	...	10 10	12 20	1 25	3 5	3 50	5 25	6 45	8 0	9 30
0⅛	Conder Greendep	8 28	...	10 13	12 23	1 28	3 8	...	5 28	6 48	8 3	9 33
4⅞	Lancasterarr	8 40	...	10 22	12 35	1 40	3 20 See note	4 15	5 40	7 0	8 15	9 45

Passenger trains Lancaster to Glasson Dock call at Conder Green to set down passengers only, and the passenger trains Glasson Dock to Lancaster call at Conder Green to pick up passengers only.

No. 8 Down and 21 Up will not run after October 31 until April.

Right: Lancaster – The Glasson Dock Line

Passenger services were withdrawn from the Glasson Dock branch with effect from Monday 7 July 1930, the last trains being run on Saturday 5 July; there were no particular ceremonies to mark the final journey, and only three passengers were carried. One or two enthusiasts' specials visited the line in its declining years, including the North Lancashire Railtour, which was headed by Fowler Class 4MT 2-6-4T No. 42316 on 1 May 1954. Six years later, on 29 May 1960, another special was hauled by Fairburn Class 4MT 2-6-4T No. 42136, while on 20 June 1964 Ivatt Class 4MT 2-6-0 (one of the regular branch engines) hauled a brake van special over the Glasson Dock route. The photograph provides a glimpse of the May 1954 special. Freight traffic ceased in September 1964, when the line was cut back to Luneside Mills, near Lancaster. Sadly, the mills were themselves run-down during the 1960s, and the last section of the Glasson Dock branch was finally abandoned in 1969.

Left: Lancaster – The Glasson Dock Line

Train services on the Glasson Dock line were never intensive, and there were, for many years, just four passenger workings each way between Lancaster Castle and Glasson. A slightly improved service was provided during the early 1920s, as shown in the 1923 working timetable. Down trains left Lancaster at 7.00 a.m., 9.10 a.m., 5.00 p.m. and 6.10 p.m. while, in the reverse direction, up workings departed from Glasson Dock at 8.25 a.m., 10.10 a.m., 1.25 p.m., 5.25 p.m. and 6.45 p.m. Additional services ran on Wednesdays and Saturdays, while the line was also served by one up and two down goods trains, together with a number of short-distance goods workings between Lancaster Castle and the Quay Sidings. Some of the train services were worked by a steam rail motor car, while others were conventional, locomotive-hauled trains consisting of two old LNWR coaches.

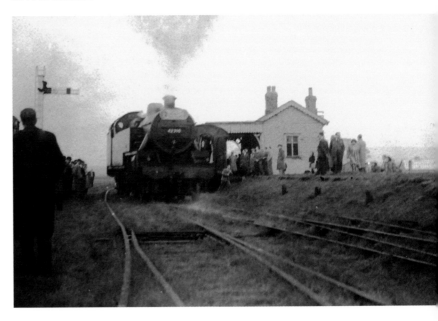

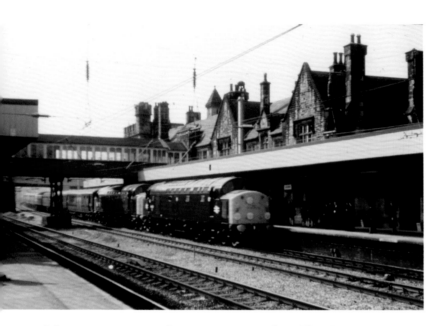

Left: Lancaster Castle – West Coast Electrification

Regular steam operation ceased on the Preston to Carlisle main line in January 1968. The replacement diesels were less powerful than the Stanier Pacifics, but this problem was solved by the use of 2,700 BHP Class 50 locomotives working in multiple on the best Anglo–Scottish workings. Of greater significance, in the longer term, was the decision to extend main line electrification northwards over the West Coast Main Line from Weaver Junction to Glasgow. The ambitious scheme was completed on 6 June 1974, when regular 25,000 volt AC electric services began running through to Glasgow, the best trains taking five hours for the 401 mile journey. The newly-electrified line was formally opened by Elizabeth II on Tuesday 7 May 1974, and the accompanying photograph shows the Royal Train entering Lancaster Castle station behind Class 40 diesel locomotives Nos 40027 (leading) and 40118.

Right: Lancaster Castle – West Coast Electrification

The Queen and Prince Philip had in fact alighted from the 'main' Royal Train at Preston in order to unveil a plaque, and Her Majesty then proceeded to Lancaster aboard a second train, which was hauled by newly-built Class 87 electric locomotive No. 87018. This second Royal Special is seen standing alongside Platform 3, the coaches visible in the picture being the test coach *Mentor* (behind the locomotive), followed by a BR Mk II first-class open coach, two Mk III coaches, and Royal Saloon No. 45000; the rearmost coach (not shown in the picture) was an inspection saloon. Saloon No. 45000 was built by the LNWR in 1920 for use as the chairman's saloon. It was rebuilt on a BR Mk 1 underframe in 1967 and fitted with B4 bogies in 1974, enabling it to travel at 100 mph.

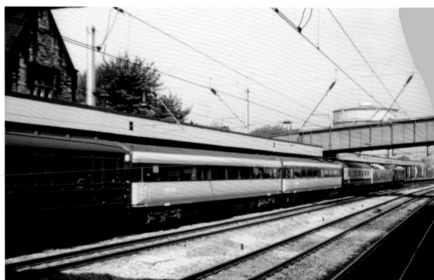

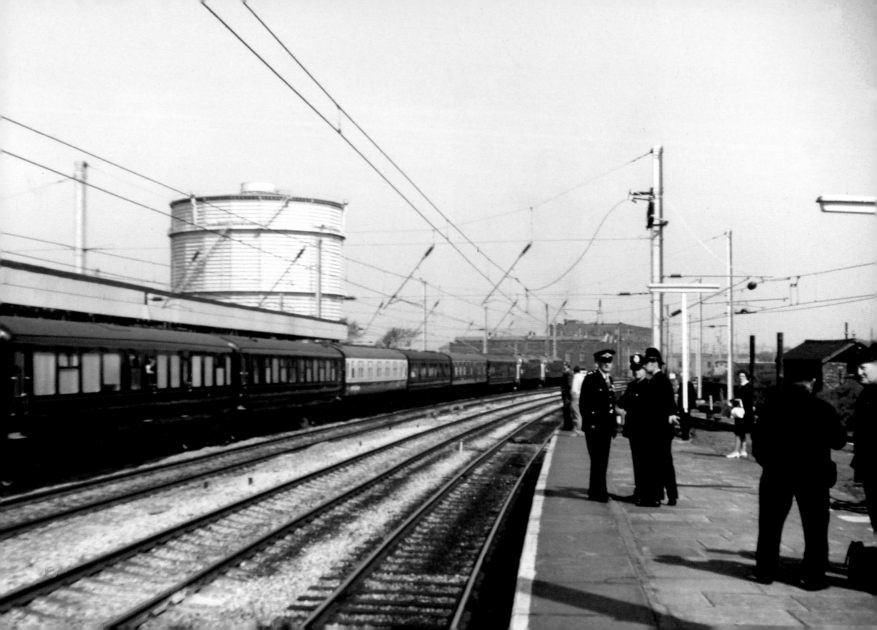

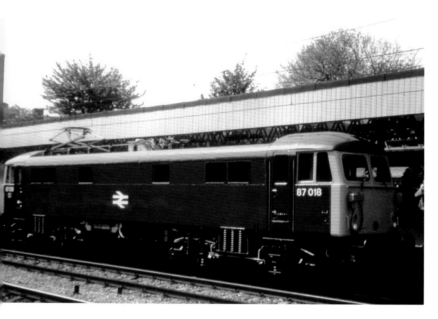

Left: **Lancaster Castle – West Coast Electrification**
A broadside view of Class 87 locomotive No. 87018 after its arrival from Preston on 7 May 1974. After a short ceremony on the platform, the Queen boarded the engine in readiness for a cab-ride to Carlisle. The Class 87 locomotives were originally un-named, but No. 87018 was named *Lord Nelson* in 1978, and it remained in front-line service on the West Coast Main Line for over thirty years. Having been displaced from main line duties by the introduction of the Pendolinos, the Class 87 locomotives were withdrawn from service and, after a period in storage, No. 87018 was scrapped in 2010.

Right: **Lancaster Castle – West Coast Electrification**
A detailed view showing Royal Saloon No. 45006, at the rear of the Royal Train on 7 May 1974. This vehicle was built by the LMS at Wolverton in 1942, utilising the underframe of a war-damaged coach. It was initially used as a director's saloon, and seconded to the Royal Train after nationalisation. The vehicle was scrapped in 1991.

Opposite: **Lancaster Castle – West Coast Electrification**
The Royal Train stands in Platform 3 on 7 May 1974.

Right: Lancaster – Thomas Edmondson

A selection of tickets issued in the Lancaster area, including two paper platform tickets and seven Edmondson cards – these tickets being particularly appropriate insofar as Thomas Edmondson (1792–1851), 'the inventor of the railway ticket', was born in Lancaster, the son of a Quaker trunk-maker. He was employed, for a time, as a cabinet-maker with the locally-based firm of Gillows & Co. Having initially been unsuccessful in business, he later found employment as a booking clerk on the Newcastle & Carlisle Railway. He found the work of filling-out paper tickets to be both boring and time-consuming, and to obviate this wasteful chore he invented the ticket-printing and dating system that still bear his name. Edmondson invented several other mechanical appliances, one of his lesser-known ideas being a mechanism which enabled women to churn butter and rock a cradle at the same time! He is commemorated by plaques in the booking hall at Lancaster Castle station and on the site of his birthplace, in Stonewall.

Opposite: Carlisle Bridge

A two-car Class 101 unit heads northwards across Carlisle Bridge while working an evening service in the summer of 1974.

Left: Lancaster Castle – The West Coast Electrification

Class 87 locomotive No. 87018 leaves Lancaster Castle with the Queen in the leading cab and Prince Philip observing the instruments in the test coach Mentor. In July 1974 *The Railway Magazine* suggested that this working was 'thought to be the first AC electric-hauled Royal Train, and certainly the first to include Mk III rolling stock'. Although full electric services commenced with the introduction of the new timetable on Monday 6 May, the first electrically-hauled passenger train to run through Lancaster had in fact been the 11.58 a.m. Carlisle to London Euston service on 10 April 1974, which was hauled by Class 87 locomotive No. 87002; two days later, the 6.03 p.m. Carlisle to Crewe service was headed by Class 86 locomotive No. 86009.

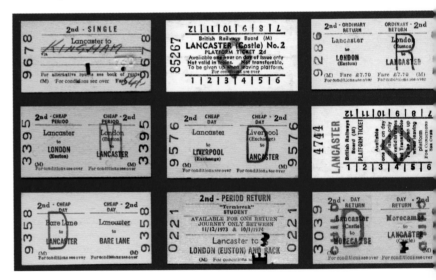

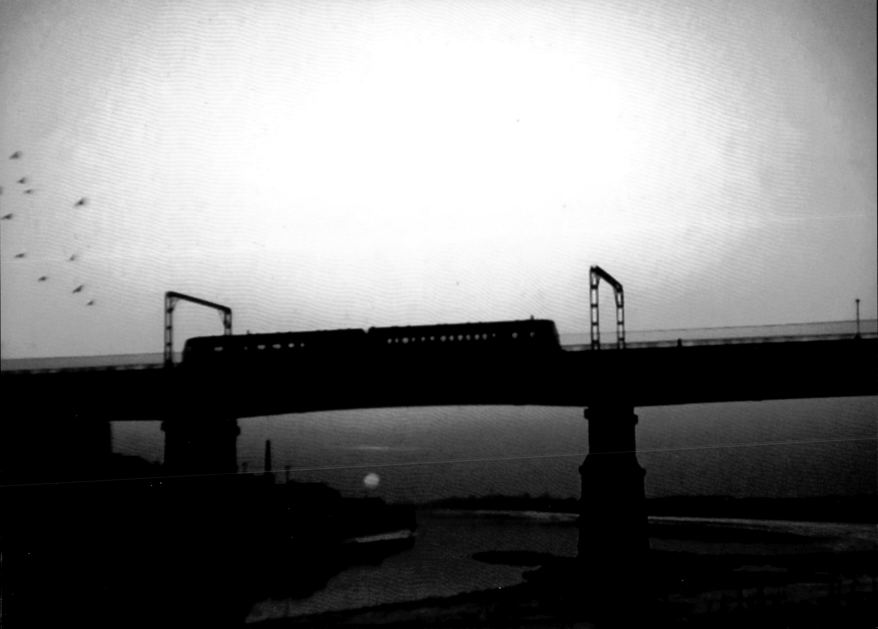

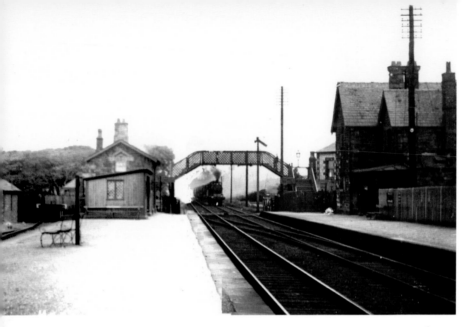

Hest Bank

On leaving Lancaster Castle station, northbound trains soon reach the spectacular Carlisle Bridge, by means of which the West Coast Main Line is carried across the River Lune. As first constructed in the 1840s, this impressive structure had consisted of three main 120-foot laminated timber spans supported on massive stone piers, with stone approach spans on each side. The viaduct was soon reconstructed with stronger centre spans, while in 1963 it was again rebuilt with reinforced concrete spans. At its north end, the viaduct crossed the Midland Railway Morecambe to Leeds line at a ninety degree angle, the Midland route being clearly visible from the soaring viaduct, which incorporates a public footbridge along its east side.

Reaching the north bank of the river, trains run through the northern outskirts of Lancaster to Hest Bank South Junction. At that point the line bifurcates, with a double track curve diverging west towards Morecambe, while the main line continues due north towards Hest Bank. Morecambe South Curve was installed in 1888 so that LNWR trains could run between Lancaster and Morecambe without reversing at Hest Bank. The curve was controlled from Morecambe South Junction Box, which was one mile forty-seven chains from Lancaster No. 4 Box. The single track Morecambe North Curve converges with the main line at Hest Bank North Junction, which is sited a short distance to the south of Hest Bank station (233.25 miles). This station was opened in September 1846 and closed with effect from 3 February 1969. It boasted a bay platform on the down side which, in later years, was occupied by camping coaches. There was also a level crossing – this feature being an unexpected part of the infrastructure on the West Coast Main Line. The upper view is looking north, while the lower photograph was taken from the seaward side of the station.

Opposite: Hest Bank

A general view of Hest Bank station, looking north towards Carlisle around 1912. The bay platform can be glimpsed to the left of the picture. The track layout was simplified in December 1958 when a new 30-lever signal box was erected beside the level crossing to obviate the need for a gate keeper. The signal box was closed in February 2013, and the crossing is now controlled by CCTV from Preston power box, although the former Hest Bank signal box has been retained as a relay room.

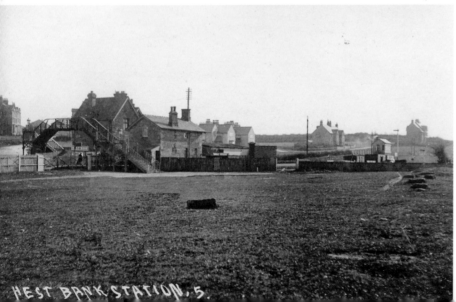

HEST BANK STATION. 5.

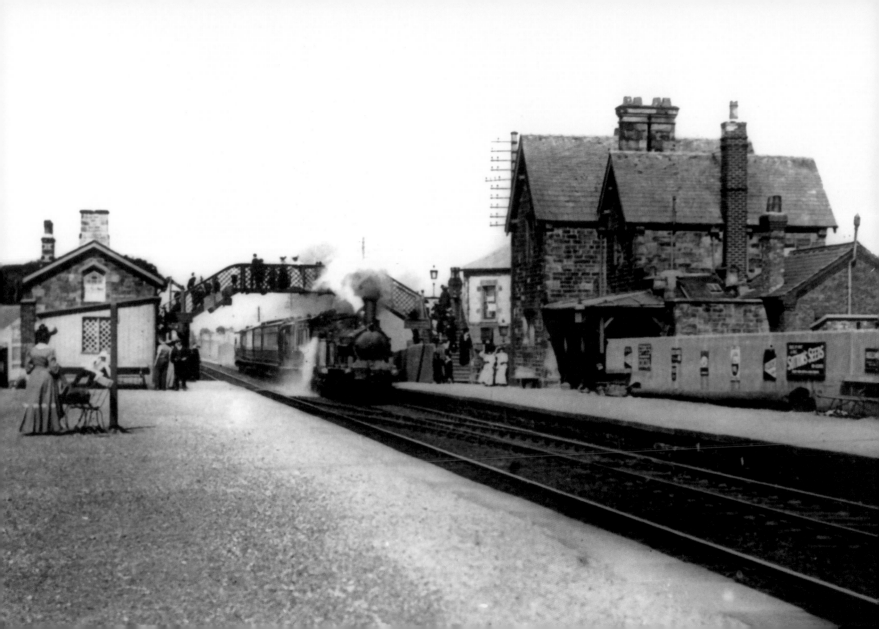

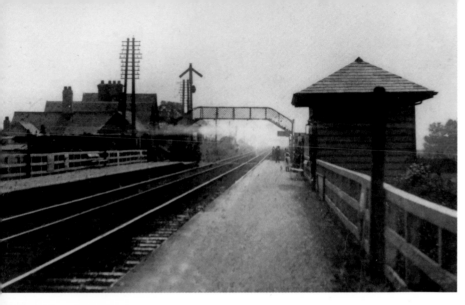

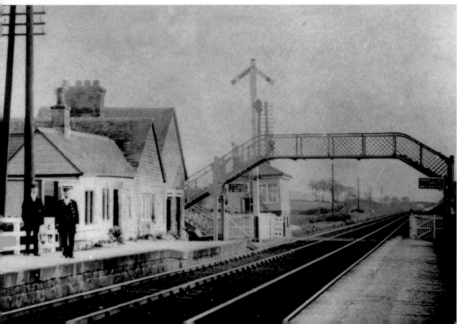

Bolton-le-Sands

Now heading north-north-eastwards, trains run along level alignments to Bolton-le-Sands (234.5 miles), with views of Morecambe Bay away to the left – this being the only section of the West Coast Main Line to be within sight of the sea! The history of Bolton-le-Sands station echoes that of Hest Bank, insofar as this wayside stopping place was opened by the Lancaster & Carlisle Railway around 1848, and closed by BR with effect from 3 February 1969. The station, originally known simply as Bolton, was renamed Bolton-le-Sands to prevent confusion with the industrial town of the same name. The photographs provide a glimpse of the station during the early years of the twentieth century.

Carnforth – Origins of the Station

Carnforth, some 236.75 miles from Euston, was opened on 22 September 1846. It was, at first, merely a wayside station serving local villages such as Kellet on the east side of the railway, and Warton and Yealand Conyers to the west. Yealand was, in fact, considered to be a more important place than Carnforth itself, and for this reason the station was referred to in early timetables as 'Carnforth-Yealand'.

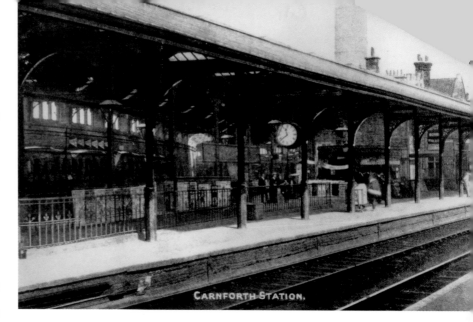

The opening of the Ulverston & Lancaster Railway in 1857 transformed the original stopping place into a busy junction, and the station facilities were further improved following the completion of the Furness & Midland Joint line on 6 June 1867. By the 1880s, Carnforth had developed into a V-shaped junction station, with its up and down main line platforms to the east and an additional platform for Furness line services on the west side. The main up platform incorporated a south-facing bay, while two north-facing bays were provided for Midland traffic, the Midland bays being sited between the LNWR and Furness lines. The main booking office and waiting-room facilities were on the up side, while an additional booking office was situated on the down side.

The up side station building is a single-storey structure with a gable roof. It is constructed of 'snecked' stonework, whereby regular courses are interrupted at intervals by larger blocks of shaped stone to produce a patterned effect. The platform-facing façade, which was formerly equipped with extensive platform canopies, has a flat, slab-like appearance, but the rear elevation is enlivened by the provision of three symmetrically-placed gables. The windows have stone mullions and square heads, the general effect being reminiscent of the Tudor period.

The down side station buildings are architecturally similar to those on the up side, but their ground plan is roughly triangular, insofar as they occupy the space between the main line and the Furness platforms. Part of the down side building rises to one-and-half storeys, and there was, at one time, a separate entrance on the north side. The accompanying photographs show the station during the Edwardian period, around 1908.

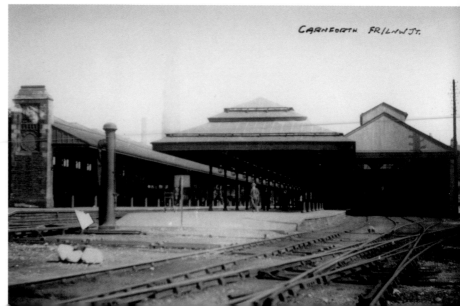

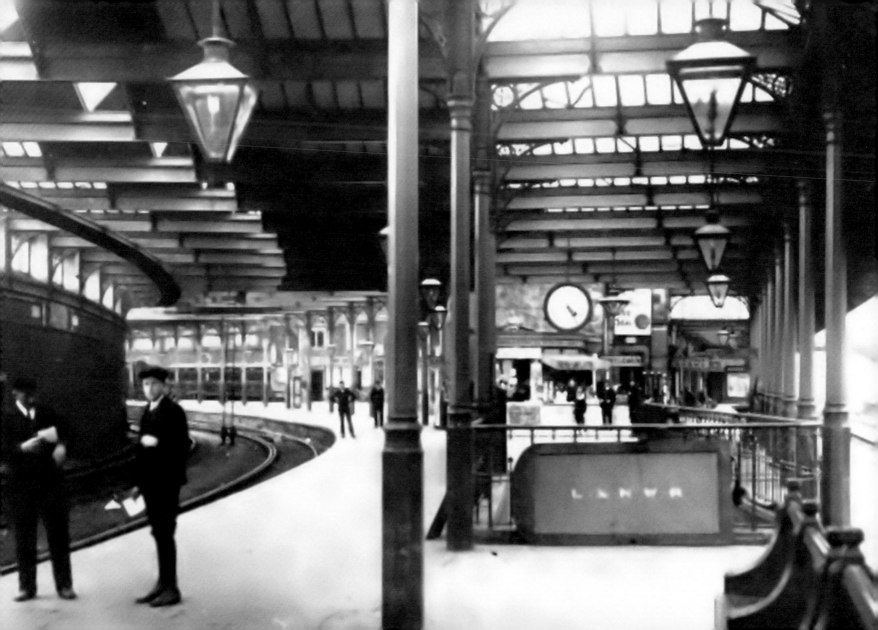

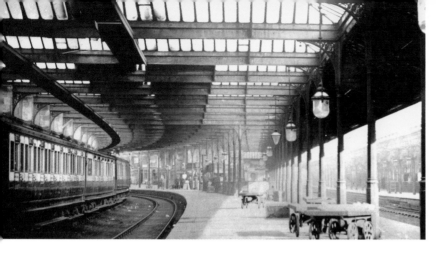

Right: Carnforth – Reconstruction of the Furness Platforms

The western side of the station was rebuilt during the 1930s, when the LMS remodelled the Barrow line platforms. Prior to this rebuilding operation, the Furness part of the station had consisted of a single curved platform with additional bays for terminating services. There was a through line to the west of the platform line, and the entire Furness side was covered by a cavernous overall roof. As part of the LMS improvements, the overall roof was taken down and an additional platform was installed alongside the second track – the new platform becoming the down Barrow platform, while the earlier platform was used for up traffic. The terminal bays at the north end of the original platform remained in situ, but an entirely new platform covering was constructed on the west side of the station, this new facility having a vaguely Art Deco appearance, which must have been strikingly modem when it was completed around 1938.

Opposite: Carnforth

This Edwardian postcard scene shows the station around 1908, the Furness platform being to the left, while the main line platforms (now removed) can be seen to the right. The platforms are linked by an underline subway with gently sloping ramps to facilitate the movement of platform trolleys, and in this context it is worth mentioning that, in the steam days, Carnforth was an important postal distribution centre, and a major stopping place for overnight postal trains on the West Coast Main Line.

Left: Carnforth

A further view of the station during the early 1900s. Carnforth was, for many years, little more than an enlarged village, its population, around 1950, being no more than about 3,500. The station handled little originating freight traffic although, prior to its closure in 1929, the Carnforth Haematite Co. had operated a rail-served ironworks that incorporated around five blast furnaces and two Bessemer converters for steel manufacture. The 1938 Railway Clearing House *Handbook of Stations* reveals that the station could handle a full range of traffic, including coal, livestock, furniture, vehicles, and general merchandise. A 10-ton crane was able to deal with the heaviest consignments, while the former Carnforth Haematite Iron Company sidings were listed as the T. W. Ward & Co. 'slag siding'. A further private siding, on the north side of the Ulverston and Lancaster route, served a nearby quarry.

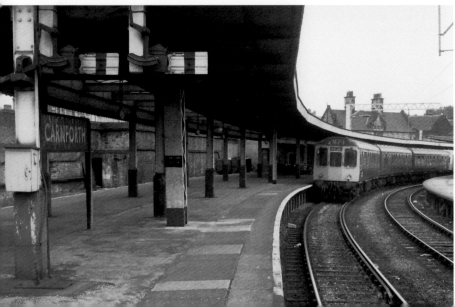

Carnforth – *Brief Encounter*

Carnforth station is famous through its association with the much-loved British film *Brief Encounter*. Made during the closing months of the Second World War, and released in 1946, *Brief Encounter* was based upon a play by Noel Coward that told the bittersweet story of illicit lovers who were able to meet, only fleetingly, in the refreshment room of an LMS station in a fictitious provincial town. The film was directed by David Lean, and starred Trevor Howard and Celia Johnson, together with the character actors Stanley Holloway and Joyce Carey, who played a ticket collector and the manageress of the refreshment room respectively – their relentlessly cheerful working-class banter being used to emphasise the moral dilemma faced by the main protagonists.

Filming is said to have taken place at Watford Junction and Carnforth, Watford having been the initial choice, although wartime blackout regulations and the threat of German flying bombs had prompted a move to the safer environs of North Lancashire. Cinema enthusiasts have claimed that all of the external railway scenes were shot at Carnforth, notwithstanding the fact that, in a recorded interview, David Lean had unambiguously stated that Watford Junction was also used during the filming.

Most of the railway scenes were shot at night to create a suitably gloomy atmosphere and, although the station sequences were incidental to the plot – they appear throughout the film – the recurrent image being that of LMS steam locomotives pounding through the dimly-lit, rain-swept station to the strains of Sergei Rachmaninov's 'Second Piano Concerto'. The station clock features prominently in several scenes, although in reality its actual face was covered by a 'false' clock-face with movable hands that could be adjusted to reflect the chronology of the unfolding story! At the end of the film, Trevor Howard takes the only course open to a gentleman of honour and terminates his liaison with Celia Johnson – his final departure for distant Johannesburg being, perhaps the most famous 'station goodbye' sequence ever filmed.

The colour picture shows the famous *Brief Encounter* clock on a dismal day in July 1999, while the black-and-white view shows a multiple unit formation in the Barrow platforms; the station has since been extensively refurbished.

Carnforth – The 'Darkest, Draughtiest Station in England'?

It would probably be true to say that, for many years, Carnforth station has had a bad press – its reputation having been utterly traduced by the classic railway writer A. H. Ahrons, who claimed that 'to the uninitiated, Carnforth might appear to be a place of some importance but, to be truthful, it must be said that it is hardly a place at all... When the wayfarer gets outside Carnforth station he shows a great alacrity either in getting to the hills to the northward or in making a return bee-line for the station'.

In similar vein, a modern writer has opined that Carnforth station 'typified Victorian architecture at its worst. Along with Oxenholme, Tebay and Penrith it formed a group of four of the darkest, draughtiest and ugliest stations in England, although to be fair the township of Carnforth was little better'. In retrospect, it should be pointed out that when Ahrons made his unflattering views known, Carnforth would still have been regarded as a relatively 'new' town, whereas in recent years our opinions about Victorian architecture have changed for the better, especially when, as at Carnforth, the buildings are attractively constructed of local stone. The station has, moreover, acquired a more positive image as a result of its connections with *Brief Encounter* – the links being underlined by the provision of a heritage centre and a superbly-restored refreshment room on Platform 1, which has developed as an attractive venue for film historians, as well as railway enthusiasts.

The upper picture shows Furness Railway 4-0-4 locomotive No. 131 beneath the long-demolished FR train shed, while the lower view shows ex-Furness 0-6-0 No. 24 (as LMS No. 12505) at Carnforth in 1927.

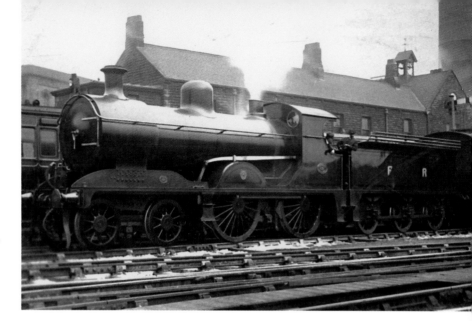

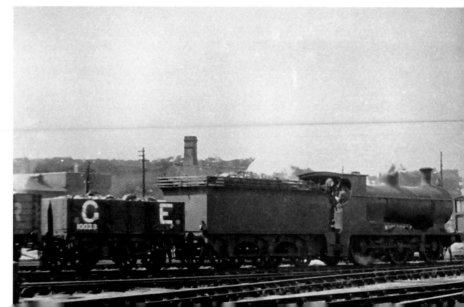

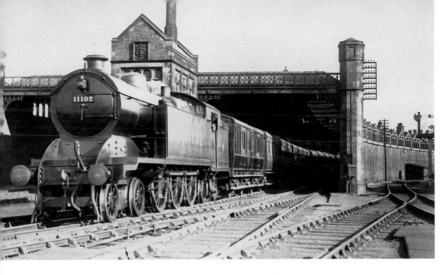

Left: Carnforth – Furness Locomotives

Furness Railway 4-4-0 locomotive No. 131 stands in the Furness platform with a Barrow working around 1914. The tall stone-built building at the north end of the up Barrow platform is referred to as 'the old signal box', and it was used as such from 1882 until 1903 – its unusual height being a concomitant of its location at the north end of what was then the Furness train shed. Writing in the February 1904 issue of *The Railway Magazine*, R. E. Charlewood stated that this distinctive building housed the offices of the Midland Railway agent, a Mr Peel. Interestingly, the building is adorned with the crest of the Cavendish family, who were major supporters of the Furness Railway.

Right: Carnforth – Furness Locomotives

Former Furness Railway 4-4-0 No. 132 (as LMS No. 10187) passes the old FR shed at Carnforth during the 1930s. In pre-Grouping days Carnforth had boasted no less than three engine sheds – each of the companies that used the station having provided their own locomotive facilities. These three locomotive depots were subsequently replaced by a modernised depot that was sited immediately to the west of the passenger station. The new engine shed, which was said to have been built by Italian prisoners of war, was constructed during the 1940s, and in January 1945 The *Railway Magazine* reported that 'the new locomotive depot of the LMSR at Carnforth, the completion of which was delayed by war conditions, has now been brought fully into use'. According to a local correspondent, the shed had 'been in partial use for a year past' as a result of overcrowding at the former LNWR shed. The report also stated that the old Midland shed had been closed.

Opposite: Carnforth – Maryport & Carlisle No. 29

Former Maryport & Carlisle Railway 0-6-0 No. 30 (as LMS No. 12514) passes Carnforth Station Junction signal box with a goods working during the 1920s. This six-coupled goods locomotive was built by the Yorkshire Engine Co. in 1919 and delivered in June 1921, together with its sister No. 29. Station Junction box was built by the Furness Railway in 1903, and it remains in operation at the north-west end of the Furness platforms.

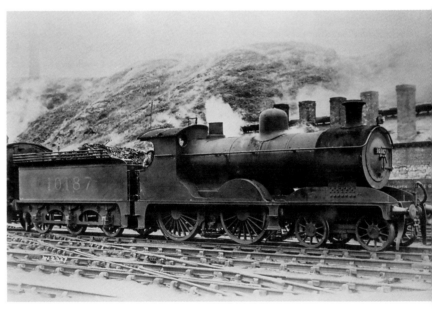

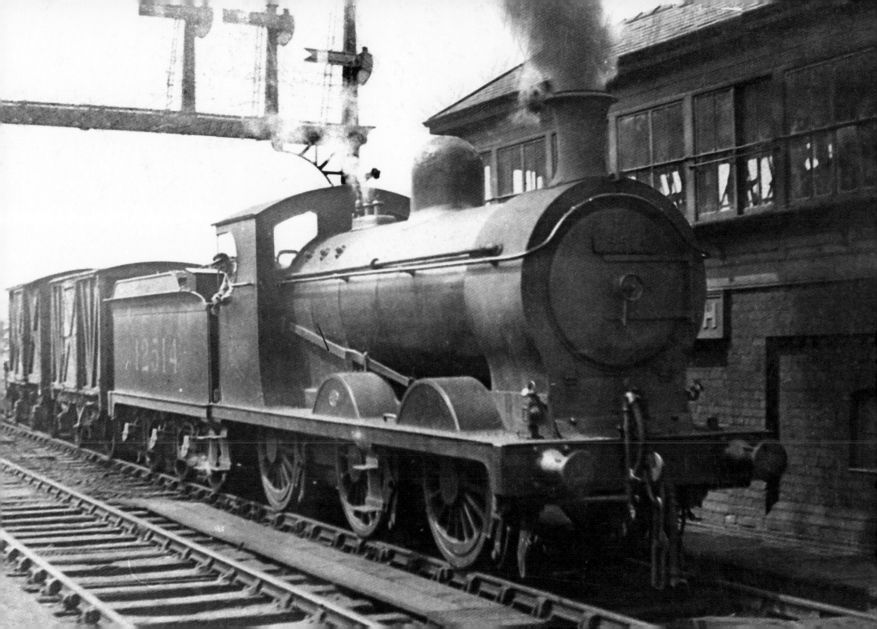

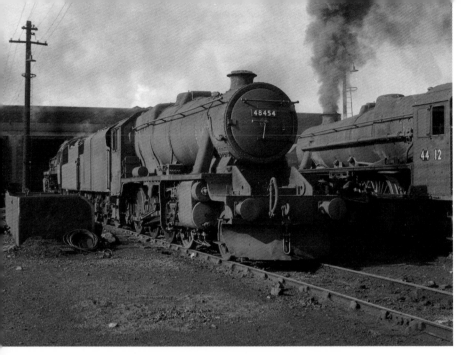

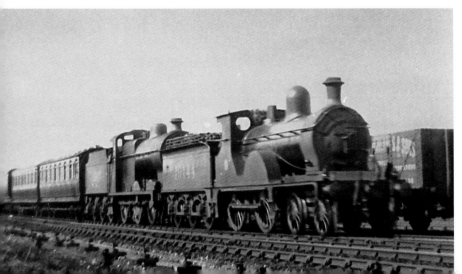

Above left: Carnforth – The Locomotive Shed

Stanier Class 8F 2-8-0 No. 48454 at Carnforth shed *c.* 1962. Carnforth shed was coded W36 in LMS days, becoming 11A during the early part of the British Railways era, 24L in 1958, and finally 10A in 1963. The six-road shed building occupied a fairly restricted site between the station and a group of marshalling and exchange sidings, a lengthy footbridge being provided at its north end for the benefit of railway staff, who would otherwise have had to walk across an expanse of sidings and goods lines. In 1950 Carnforth had an allocation of forty-two locomotives, comprising ten Stanier Black Five 4-6-0s, seven Fowler 4F 0-6-0s, three 3MT 2-6-2Ts, nine 7F 0-8-0s, seven 4MT 2-6-4Ts and six Class 3F 0-6-0T shunting locomotives. The shed was equipped with the usual locomotive turntable and a prominent mechanical coaling tower.

In 1967, Carnforth shed became the Steamtown Carnforth preservation centre, with locomotive owner Dr Peter Beet as its chairman. A number of privately owned engines were based there including Stanier Black Five Class 4-6-0s, and former SNCF Chapelon Pacific, No. 231K22, which worked on a demonstration line within the site. When British Rail allowed steam locomotives to operate on the main line system, Carnforth became the main base for steam engines working on the Cumbrian coast and Settle and Carlisle routes. However, the owners of the site gradually reduced the enthusiast opening days, and the site has now been developed as a repair and maintenance depot for steam and diesel locomotives owned and operated by the West Coast Railway.

Below left: Carnforth

Former Furness Railway 4-4-0 locomotive No. 127 (as LMS No. 10144) pilots ex-Midland Class 4F 0-6-0 No. 4392 at the head of a Barrow to Manchester working at Carnforth during the early LMS period.

Opposite: Carnforth

Class 37 locomotives Nos 37047 and 37058 arrive at a rain-swept Carnforth station with the 12.30 p.m. Pathfinder Tours Rylstone Quarry to Reading Summer Syphony rail tour on 17 July 1999. The train is negotiating the sharp curve that connects the Furness & Midland line to the Furness route. The 'old signal box' features prominently to the right.

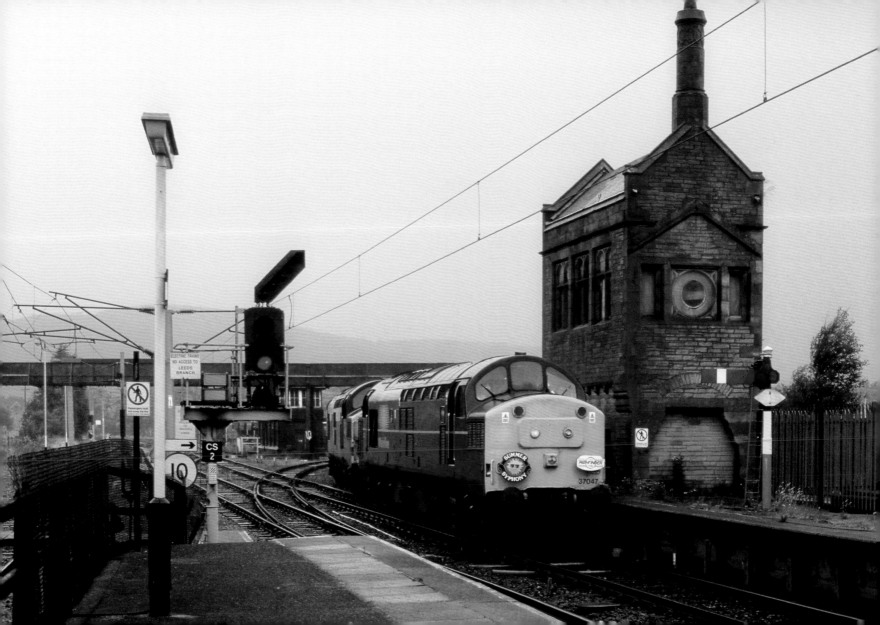

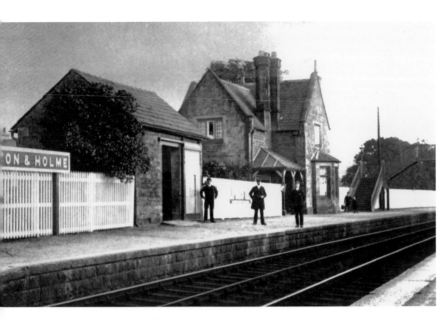

Right: Burton and Holme

The 1.40 p.m. Virgin West Coast Glasgow to Euston Caledonian service is illuminated by a brief patch of dramatic lighting as it heads southwards through attractive countryside near the site of Burton and Holme station on 25 April 1998, the leading vehicle being DVT No. 82138. The bridge in the background carries the B6384 Holme to Milnthorpe road across the railway.

Opposite: Burton & Holme

HST power car No. 43099 leads the 7.15 a.m. Virgin CrossCountry Penzance to Edinburgh Cornish Scot service past the flooded fields near Burton and Holme on 25 April 1998. There had recently been a long spell of particularly heavy rain, causing the River Bela to burst its banks. The Cornish Scot was scheduled to reach Edinburgh Waverley at 4.25 p.m., having accomplished its lengthy cross-country journey in a time of nine hours.

Left: Burton and Holme

Continuing north-north-eastwards through pleasant countryside, down trains soon pass the site of Burton and Holme station (240.75 miles), which was opened in September 1846 and closed with effect from 27 March 1950. The infrastructure here was similar to that found at other wayside stations on the Lancaster and Carlisle route, the main station building being another Tudor-gothic style structure that incorporated a two-storey station master's house in addition to the usual booking office and waiting room accommodation. The building was of stone construction with tall chimneys, small-paned windows and a rustic veranda for the benefit of travellers during periods of inclement weather. The up and down platforms were linked by a footbridge, and the fully equipped goods yard was able to handle all forms of traffic.

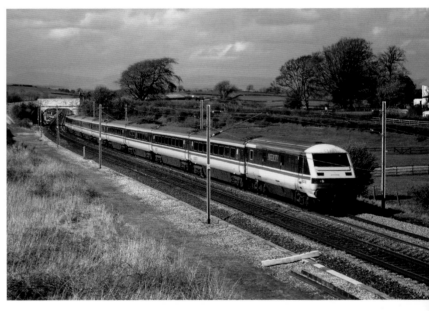

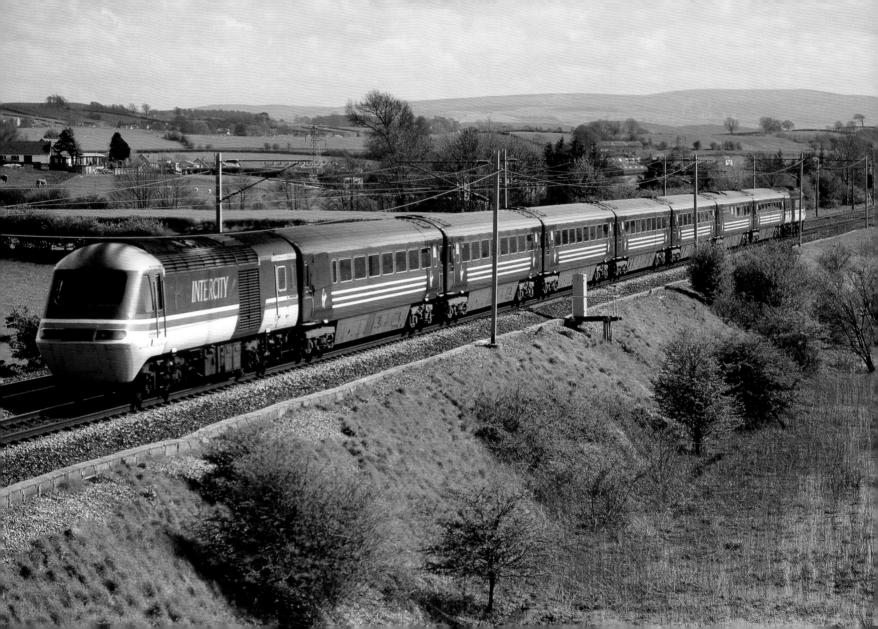

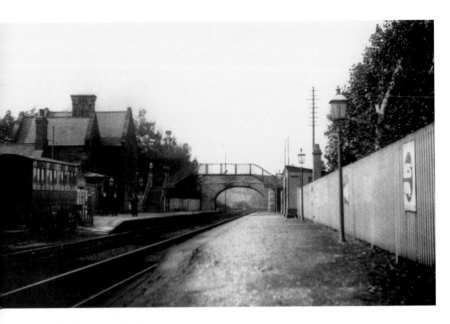

Left: Milnthorpe

Milnthorpe, the next stopping place (243.25 miles), was around two-and-a-half miles further on. Opened with the line on 21 September 1846, this wayside station was closed with effect from 1 July 1968. The infrastructure here consisted of up and down platforms for passenger traffic, the Tudor-gothic station building being on the down side. The road from Milnthorpe to Crosslands was carried over the line on a single-span bridge at the north end of the platforms, while the up platform was equipped with a small waiting shelter. The goods yard was able to deal with a full range of traffic including coal, livestock, vehicles, furniture, horse boxes and general merchandise, while a private siding served an adjacent milk factory which received milk from an area extending from south-west Cumberland to north-east Yorkshire. The photograph is looking north towards Carlisle around 1912.

Right: Oxenholme

Continuing northwards on rising gradients as steep as 1 in 111, trains pass the site of Hincaster Junction, at which point a former Furness Railway branch from Arnside had formerly trailed-in from the left. This 5.25 mile line, which provided a shorter route for mineral traffic between Furness and the north-east, was brought into use on 26 June 1876 and closed in 1963. Oxenholme, the next station (249.5 miles) was opened with the first section of the Lancaster & Carlisle Railway on Tuesday 21 September 1846, and it became a junction on 17 December of that same year, when the L&CR was completed throughout to Carlisle. The passenger facilities provided were, at first, extremely limited – the station being little more than an exchange point between the Kendal branch and the main line, although in March 1852 it was reported that 'the permanent stations at Oxenholme and Tebay' had been 'nearly completed'. The photograph provides a panoramic view of the station during the early 1900s.

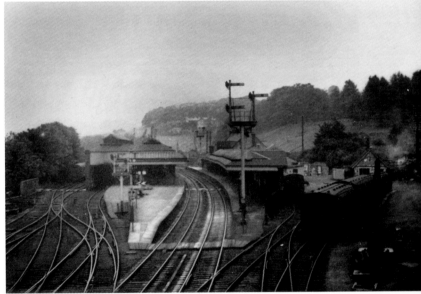

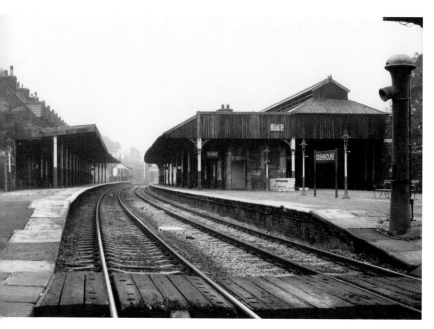

Left: Oxenholme

The station has up and down platforms for main line traffic, together with an additional platform for Windermere branch trains on the down side – the down platform being an island with tracks on either side. The platforms are linked by an underline subway, and the main station buildings are on the up side, while the branch platform is covered by a barn-like overall roof. In architectural terms, Oxenholme is another Tudor-gothic style station, although the stone station buildings are less flamboyant than their counterparts at Lancaster and Carlisle – the main station building being a gable-roofed structure with squat chimney stacks and a row of dormer windows above the full-length platform canopy.

Right: Oxenholme

An overall view of the station, looking north towards Carlisle, probably during the early years of the twentieth century. The goods yard was able to deal with coal, livestock, furniture, vehicles, horse boxes and general merchandise, and there was a 5-ton yard crane. The infrastructure at Oxenholme also included a four-road engine shed which, in the BR period, normally had an allocation of about eight Class 4MT 2-6-4Ts and Class 3F 0-6-0Ts. These locomotives were employed on the Windermere branch, and as bankers for northbound traffic on the rising gradients towards Grayrigg. The shed was closed in 1962 and its locomotives were then transferred to Carnforth.

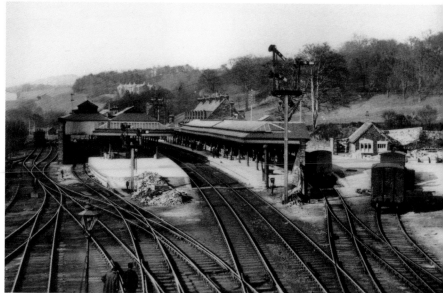

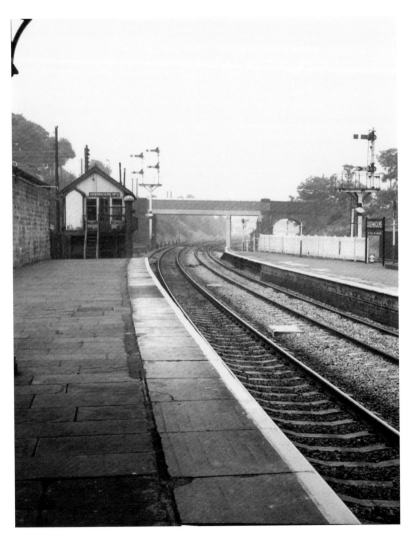

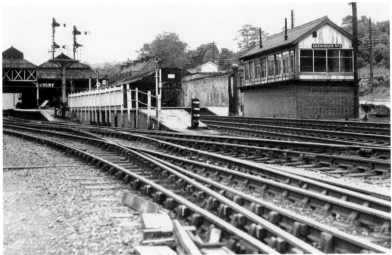

Oxenholme

Above: A further view of Oxenholme station, looking north towards Carlisle during the British Railways period around 1960. The branch line platform, with its somewhat gloomy train shed, can be seen to the left, while Oxenholme No. 2 signal box features prominently on the right. The latter structure was of LMS origin. The branch is physically connected to the West Coast Main Line at the south end of the station, whereas in steam days there had also been a double track connection between the branch and the main line at the north end of the down platform. This connection was removed around 1968, and the down platform was then extended northwards.

Left: This photograph (*c*. 1960s) is southwards along the main up platform, with Oxenholme No. 2 signal box visible in the middle distance. Oxenholme has remained a regular stop for InterCity services, and in recent years it has generated around 400,000 passenger journeys per annum. The station was renamed Oxenholme Lake District in 1988.

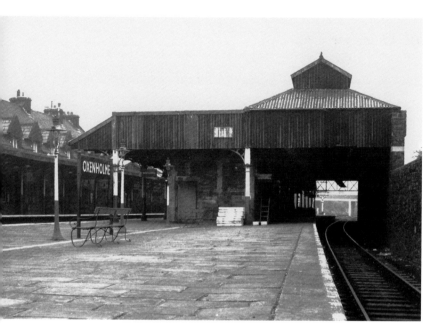

Right: The Windermere Branch

As mentioned in the historical section, the Windermere branch was ceremonially opened as far as Kendall on 21 September 1846 and completed throughout to Windermere in the following year. The line was double-tracked throughout, with intermediate stations at Kendall, Burnside and Staveley, while at Windermere the railway ended with some formality in a surprisingly grand terminus, as shown in this Edwardian postcard view. The line was, from its inception, a popular tourist route and, as late as 1965, it was still served by a named train – the Lakes Express being an important through service from London Euston. Although the branch avoided closure during the Beeching years, the route was down-graded following the introduction of a full electric service between Euston and Glasgow in 1974.

Left: Oxenholme – Two Violent Incidents

A detailed view of the Windermere branch platform, looking south towards London Euston around 1965, the main station building being visible to the left. Oxenholme station was the setting for a murder on 10 February 1965, when thirty-six-year-old Police Constable George William Russell was shot dead while trying to arrest an armed suspect who had taken refuge in the waiting room; two other policemen were injured in the incident. PC Russell, who is commemorated by a memorial bust on the wall of Carlisle Cathedral, was posthumously awarded the Queen's Police Medal for gallantry. A second murder took place on 25 May 2006 when 19-year-old Thomas Grant, an undergraduate at the University of St Andrews, was stabbed to death aboard an InterCity train. The train manager managed to lock the assailant into a coach, but he smashed a window and escaped when the train drew to a stand at Oxenholme. It transpired that the murderer had no less than twenty-one previous convictions for theft and other misdemeanours.

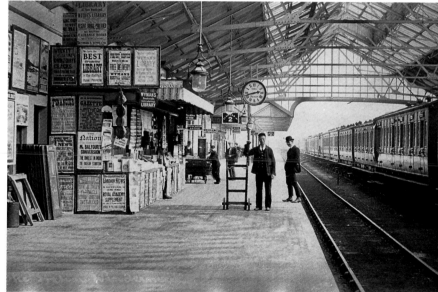

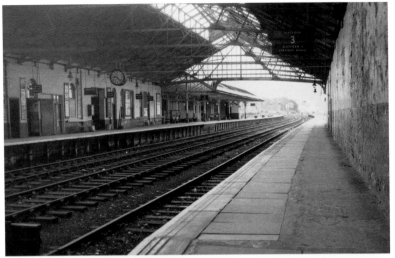

The Windermere Branch

Left: This Edwardian postcard shows the interior of the terminus at Windermere, which boasted four platforms and an impressive overall roof – the station being an important destination for Lake District traffic.

Below left: A later view of the station, looking north towards the terminal buffer stops along Platform 2 – the main departure platform. The Windermere branch was reduced to single track in 1973, and the station was down-sized in 1986, when the train shed and the original station buildings were converted into a supermarket; the present station has just one platform, together with a modern, brick-and-timber station building that was formally opened on 17 April 1987.

Below right: Class 20 locomotives Nos. 20075 and 20131 pass Staveley with the 8.30 a.m. Pathfinder tours Crewe to Preston (via Windermere) rail tour on 23 May 1993. This was one of a number of 'mini excursions' run on that day; Class 37 locomotives Nos 37708 and 37801 can just be discerned at the rear of the train.

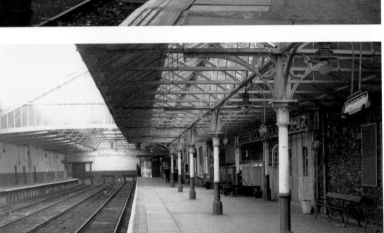

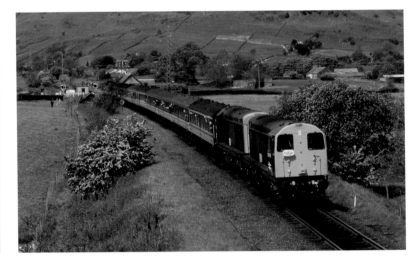

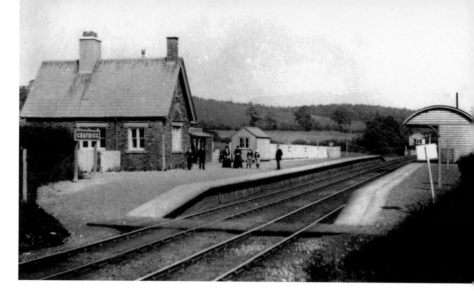

Grayrigg

On leaving Oxenholme, trains run due north for a distance of about two miles, after which the route curves eastwards through 90 degrees as it climbs on gradients of 1 in 131 and 1 in 106. Having crossed the six-arch Docker Viaduct, down workings pass the site of Grayrigg station (256.25 miles), which was opened by the Lancaster & Carlisle Railway in 1848. The station was, at first, no more than very basic halt, but a station building and other permanent facilities had been erected by 1861. The station was situated on a slight curve, with its main station building and goods yard on the down side.

The track layout was altered during the 1920s when refuge loops were added on both sides of the running lines; this, in turn, necessitated an alteration in the platform arrangements - the up platform being reconstructed on a new alignment, which was slightly further to the east than its counterpart on the down side. The staggered platforms were linked by a barrow crossing, a fenced-in pathway being provided between the crossing and the up platform ramp, so that passengers could cross the line in safety.

The upper photograph shows this wayside stopping place during the early years of the twentieth century, while the lower view is a detailed study of the cottage-style station building. This small station derived its name from that of a nearby village, which was named after the local squire, Mr Gray Rigge, who owned some of the land that had been needed during the construction of the Lancaster and Carlisle line. Grayrigg was, sadly, deleted from the railway system with effect from 1 February 1954.

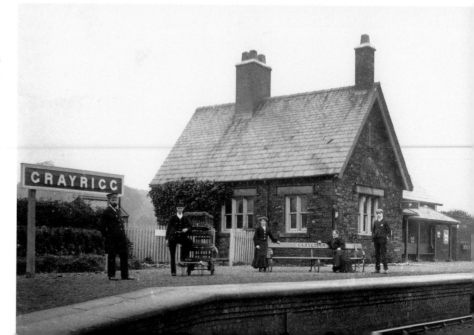

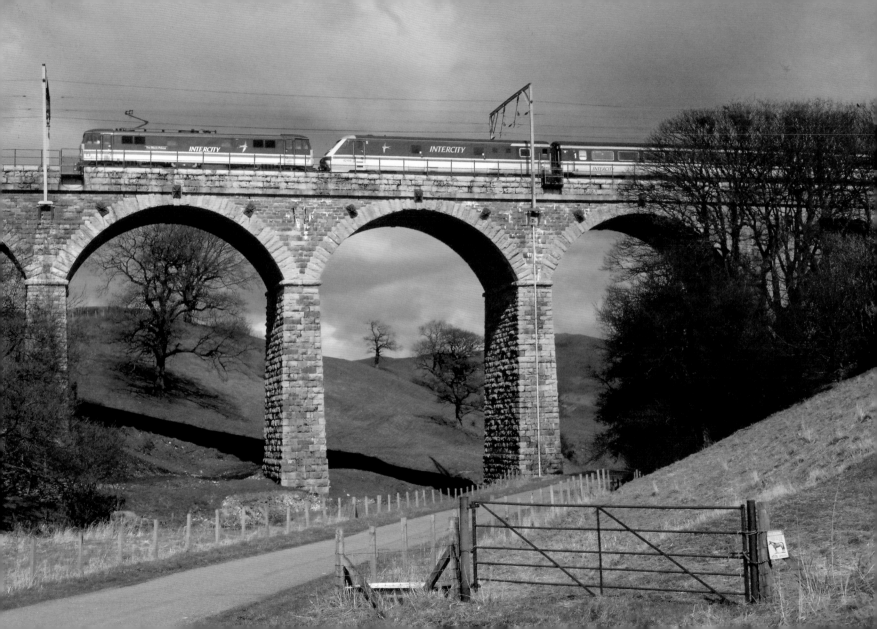

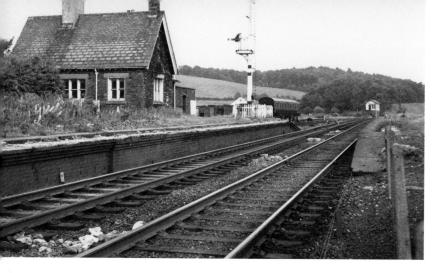

Right: Low Gill

After heading eastwards for about four miles, the line curves back towards the north as it approaches the closed stopping place at Low Gill (258 miles). This station was opened on 17 December 1846, but it achieved greater operational significance when the Ingleton branch was brought into use on 16 September 1861. Low Gill thereby became a junction for branch services to Kirkby Lonsdale, Ingleton and Clapham (Yorks), although it would probably be true to say that this cross-country link never achieved its potential as a through route. The infrastructure here included up and down platforms for main line traffic, and a low-level platform for branch line services. The main station building, a squat, hip-roofed structure, was situated on the main up platform, and the signal box was sited to the north of the platforms on the up side.

Opposite: Docker Viaduct

Under a menacing sky, Class 87 electric locomotive No. 87011 *The Black Prince* leads DVT No. 82104 across Docker Viaduct with the 9.50 a.m. Glasgow to Euston Royal Scot service on 29 March 1997. This impressive viaduct towers 7½ feet above local ground level, while its total length is 123 yards.

Left: Grayrigg

A post-closure view of Grayrigg station, looking north towards Carlisle during the 1960s. Grayrigg has been the setting for two accidents. On 18 May 1947 the 10.00 a.m. Glasgow to Euston service, headed by Stanier Pacific No. 6235 *City of Birmingham*, collided with a light engine on Docker Viaduct after the driver of the express had failed to notice a warning signal; the crew of the light engine sustained minor injuries, while three passengers and one of the dining car cooks were detained in hospital. A much worse incident occurred on 23 February 2007 when Virgin Trains Pendolino unit No. 390033 *City of Glasgow*, carrying over a hundred people, was involved in a high-speed derailment when approaching Grayrigg while working the 5.15 p.m. service from London Euston to Glasgow. The leading power car and five coaches plunged down an embankment, causing the death of eighty-four-year-old Margaret Masson, while a further thirty passengers sustained serious injuries. It transpired that the accident was caused by a poorly-maintained crossover. Although this incident was regrettable, it underlined the strength and solidity of the Pendolino vehicles, all of which remained more or less intact.

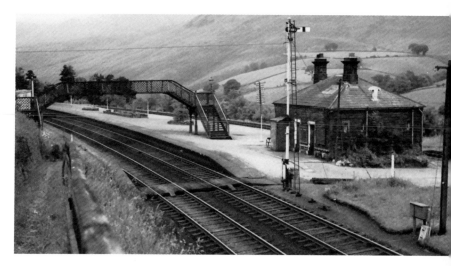

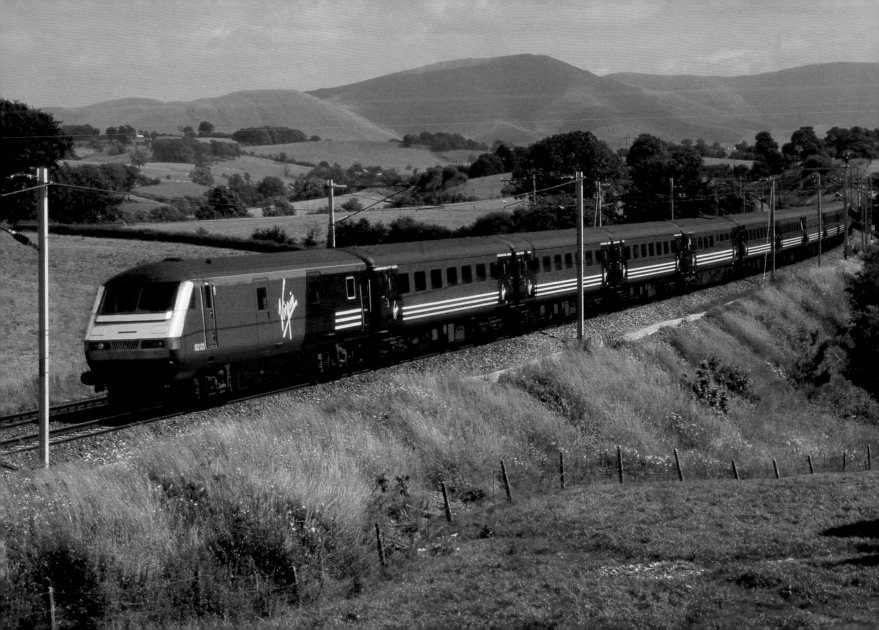

Low Gill

Right: An old view of Low Gill station, looking north towards Carlisle around 1900. The goods yard, with provision for coal class traffic and general merchandise, was on the 'branch line' side of the station. The main line platforms were linked by a lattice girder footbridge, while passengers reached the branch line platform by means of a barrow crossing. This was, in effect, the second Low Gill station – the original 1846 stopping place, about three-quarters of a mile to the south, having been resited in connection with the opening of the Ingleton branch in 1861. In its very early days, the station had been known as Lambrigg.

Below left: There were five viaducts on the Ingleton branch, including Ingleton Viaduct, which had eleven arched stone spans.

Below right: Kirkby Lonsdale was one of six intermediate stations on the Low Gill to Clapham route.

Opposite: Grayrigg

DVT No. 82123 leads the 11.48 a.m. Glasgow to Euston Virgin service past Docker on 12 July 2003; this is an ideal photographic location on a sweeping curve with hills rising dramatically in the background.

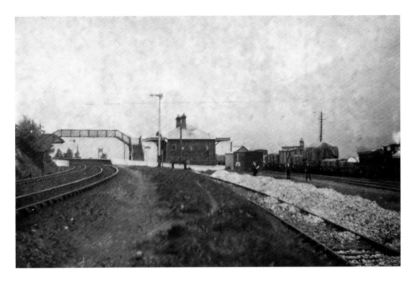

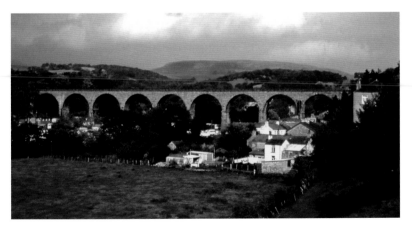

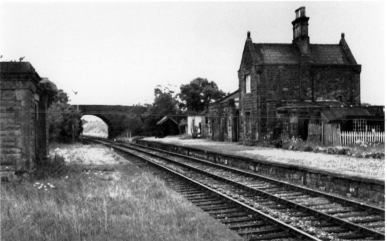

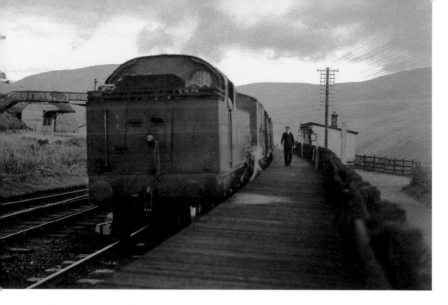

Right: Low Gill

Class 47 locomotive No. 47781 *Isle of Iona* sweeps round the curve at Low Gill while heading the 5.45 a.m. Pathfinder Tours Didcot to Carlisle Cumbrian Mountain Express rail tour on 16 September 1995. The locomotive is sporting Rail Express Systems red livery, while the Mk.1 coaches are well turned-out in early British Railways crimson and cream livery. The Class 47 was replaced at Carlisle by the highlight of the tour – LMS Princess Royal Class 4-6-2 No. 46203 *Princess Margaret* Rose, which worked the train as far as south as Crewe, where it was replaced by Class 47 No. 47780 for the final leg of the return journey to Didcot.

Opposite: Low Gill

Class 390 Pendolino No. 390022 leans into the curve at Low Gill as it speeds southwards with the 2.10 p.m. Glasgow Central to Birmingham New Street Virgin West Coast service on 6 September 2004. The Pendolinos had only just started operating Scottish services when this picture was taken.

Left: Low Gill

An unidentified Fowler Class 3MT 2-6-2T waits alongside the low level Ingleton branch platform at Low Gill with a local passenger working. The down side waiting shelter can be seen to the left, while the small waiting room provided on the branch platform can be glimpsed to the right. The Ingleton branch was closed with effect from 1 February 1954, although the line was retained as a freight and diversionary route for a further twelve years. The last ordinary passenger train, which ran on Saturday 30 January, consisted of Fowler Class 4MT 2-6-4T No. 42396 and four coaches, while the last day travellers included Lord and Lady Shuttleworth of Kirkby Lonsdale and Mr and Mrs Roger Fulford of Barbon, together with a party of their friends, many of whom were wearing Victorian clothes. The withdrawal of branch passenger services contributed to a loss of traffic at Low Gill, and the station was itself closed with effect from 7 March 1966.

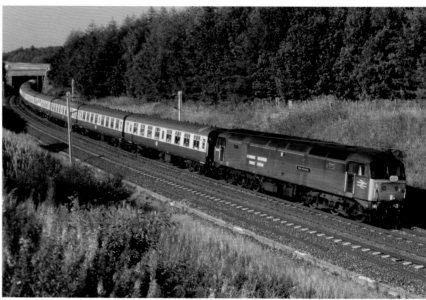

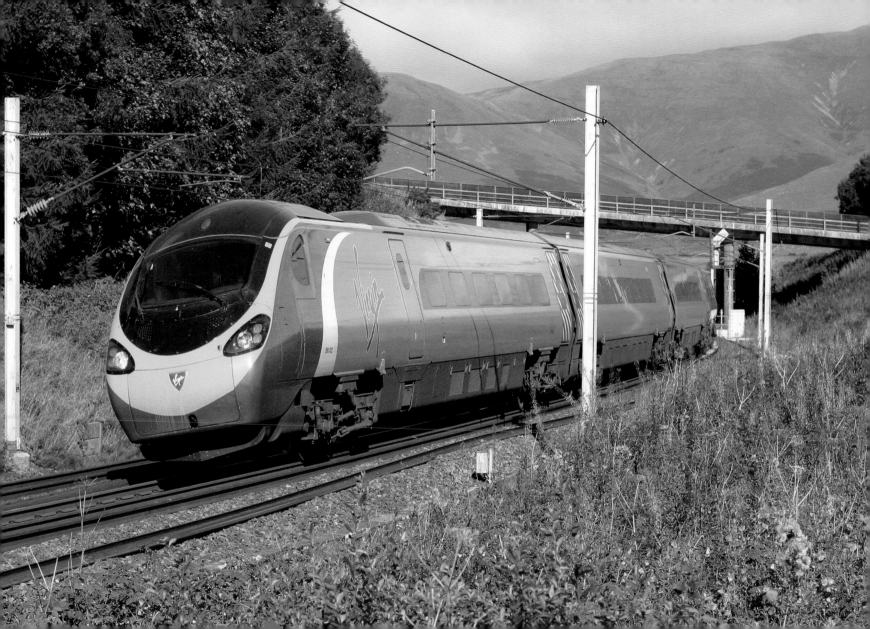

Right: **Low Gill**

Class 60 locomotive No.60047 *Robert Owen* passes Low Gill at the head of the 9.21 a.m. Carlisle to Fiddlers Ferry Merry-go-Round coal train on 16 December 1995. No. 60047 had only just received its 'Big T' Transrail livery, having previously worn Trainload Coal colours.

Opposite: **Low Gill**

Class 86 electric locomotives Nos 86605 and 86637 pass Low Gill with the 10.45 a.m. Coatbridge to Southampton Freightliner service on 29 March 1997.

Left: **Low Gill**

A southbound HST set headed by power car No.43063 *Maiden Voyager* sweeps round the reverse curves at Low Gill while hauling the 8.50 a.m. Edinburgh to Penzance Cornish Scot Virgin CrossCountry service on 29 March 1997. This service was scheduled to reach Penzance at 8.22 p.m. The M6 Motorway can be seen in the distance.

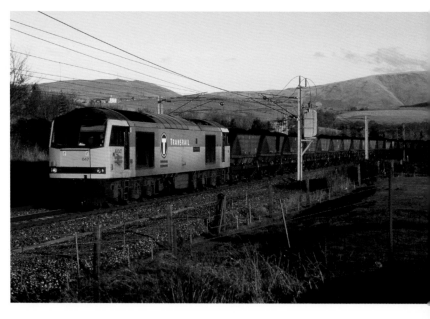

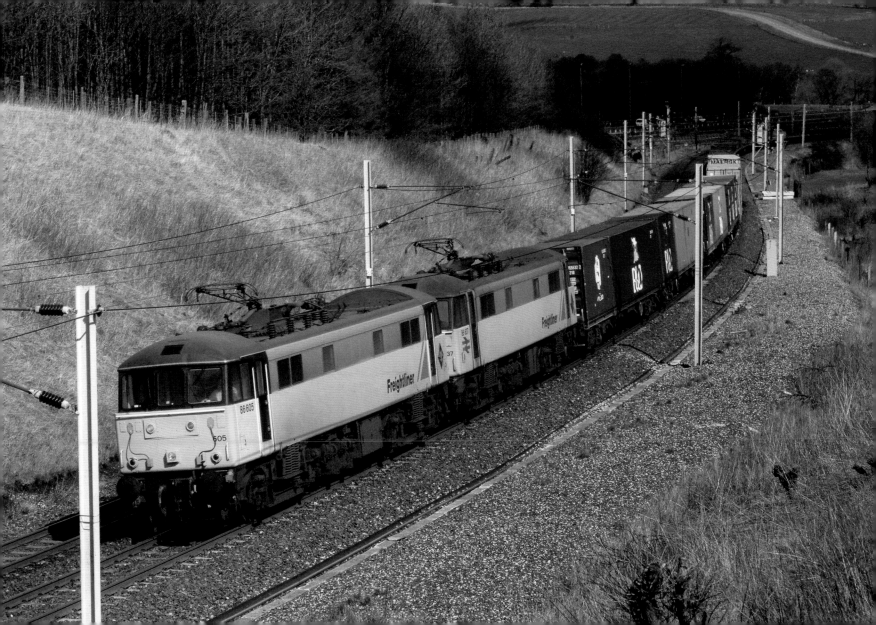

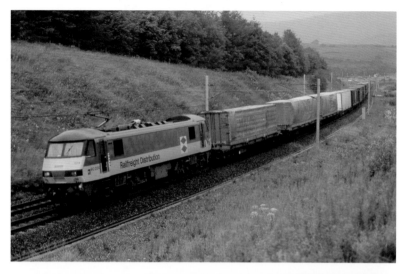

Low Gill

Left: Class 90 electric locomotive No. 90024 passes Lowgill with the 10.20 a.m. Mossend to Wembley Freightliner service on 26 July 1997.

Bottom left: Peak Class 45 locomotive No. D172 *Ixion* rounds the curve at Lowgill with the 5.00 p.m. Cardiff Central to Carlisle Pathfinder Tours 'Festive Cumbrian Mountain Express' rail tour on 16 December 1995.

Below Right: In atrocious lighting conditions and pouring rain, Class 37 locomotives Nos 37609 and 37610 sweep round the curve at Lowgill with the 12.53 a.m. Penrith to Cricklewood Milkliner service on 26 July 1997. Both locomotives had recently been taken over by DRS, who had quickly applied their logos, along with small Tankliner markings midway along the body sides.

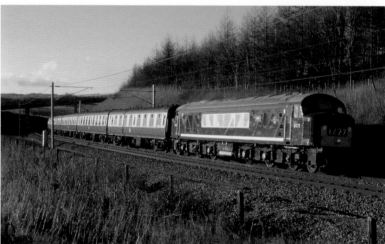

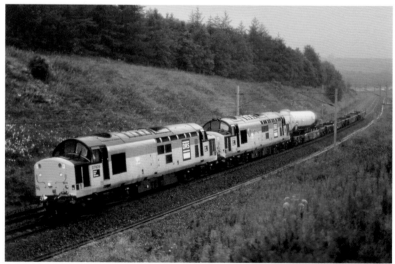

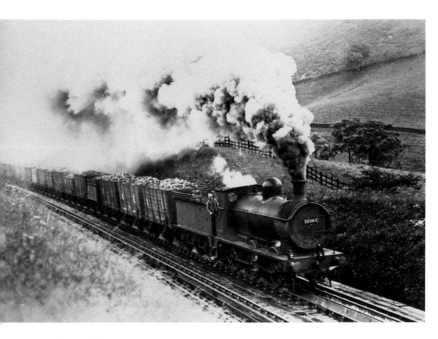

Left: Dillicar

From Low Gill, the line runs northwards along the Lune Valley, the next six miles being easily-graded, although the scenery becomes increasingly spectacular as trains approach Dillicar – formerly the site of Dillicar water troughs, which enabled the locomotives of express trains to replenish their water supplies while running at high speed. The photograph shows former Maryport and Carlisle 0-6-0 locomotive No. 29 with a freight working at Dillicar during the 1920s. No. 29 and sister engine No. 30 were a pair of powerful 0-6-0 goods locomotives that had been ordered from the Yorkshire Engine Co. in 1919 and delivered in June 1921. The order specified that the new locomotives would be 'heavy goods engines and tenders of the Hull & Barnsley type', and indeed the new engines were mechanically very similar to the H & BR L class 0-6-0s; these engines were said to have been the last non-superheated inside cylinder 0-6-0s built for main line service in the UK. They became LMS Nos 12513 and 12514 at the Grouping, and survived until December 1933 and March 1934.

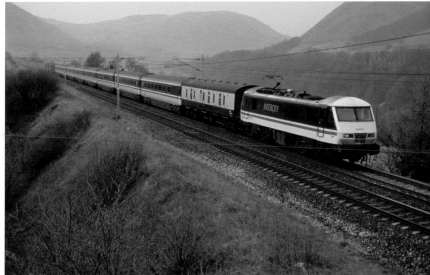

Right: Dillicar

Class 90 electric locomotive No. 90002 heads southwards through the Lune Gorge at Dillicar with the 2.40 p.m. Edinburgh to Euston Clansman on 11 April 1992. In spite of the less-than-perfect lighting conditions, the class 90's original livery shows up well; there is an interesting range of coaching stock in the train, including a blue and grey Mk1 BG at the head of the ensemble and three GUV vans at the rear, while the passenger vehicles are standard BR Mk3 coaches in InterCity livery. Although this location is situated within a few feet of the M6 motorway, it is a very long walk from any other public road!

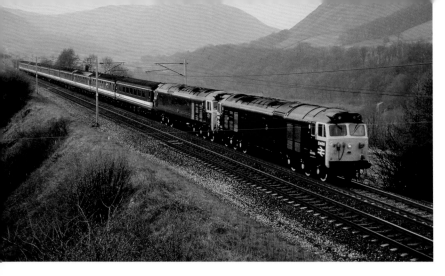

Left: Dillicar

Class 50 locomotives Nos 50050 *Fearless* (carrying blue livery as No. D400) and 50007 *Sir Edward Elgar* head southwards through the Lune Gorge at Dillicar with the returning Rail-Network Southeast Carlisle to Waterloo Carlisle Fifty Farewell rail tour on 11 April 1992. The use of two Class 50 locomotives running in multiple was a regular feature of operations on the Preston to Carlisle line prior to electrification in 1974 – the idea being that two 2,700 BHP diesel locomotives would emulate the performance of electric locomotives on Shap and Beattock banks.

Right: Tebay – The Stainmore Route

Continuing northwards through spectacular moorland scenery, trains resume their ascent, the now-closed station at Tebay (262.25 miles) being sited on a 1 in 146 rising gradient. This station was opened on 17 December 1846, and it subsequently became the junction for trans-Pennine services via the South Durham & Lancashire Union Railway, which was opened for freight traffic on 4 July 1861, and for the carriage of passengers on 8 August 1861. Engineered by Thomas Bouch (1822–80), the South Durham & Lancashire Union line linked Bishop Auckland with Tebay, and enabled Durham coke to be easily transported to the ironworks of Furness. The line was known as The Stainmore Route, and it featured fearsome gradients on either side of the 1,370 feet Stainmore Summit, and an immense lattice girder viaduct at Belah – the latter structure being similar in design to Bouch's ill-fated Tay Bridge. Tebay station, shown in the accompanying photograph, was opened on 17 December 1846 and closed with effect from 1 July 1968.

Opposite: Dillicar

Class 86 electric locomotive No. 86214 *Sans Pareil* speeds southwards through the Lune Gorge at Dillicar with the 3.26 p.m. Edinburgh to Liverpool Lime Street service on 11 April 1992. No. 86214 was named after Timothy Hackworth's pioneer steam locomotive Sans Pareil, which took part in the famous Rainhill Trials on the Liverpool & Manchester Railway in 1829.

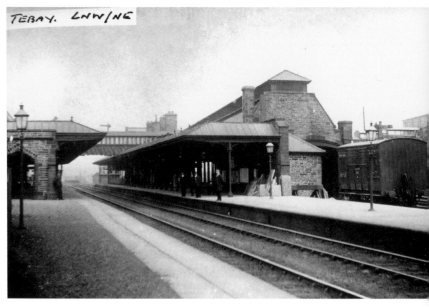

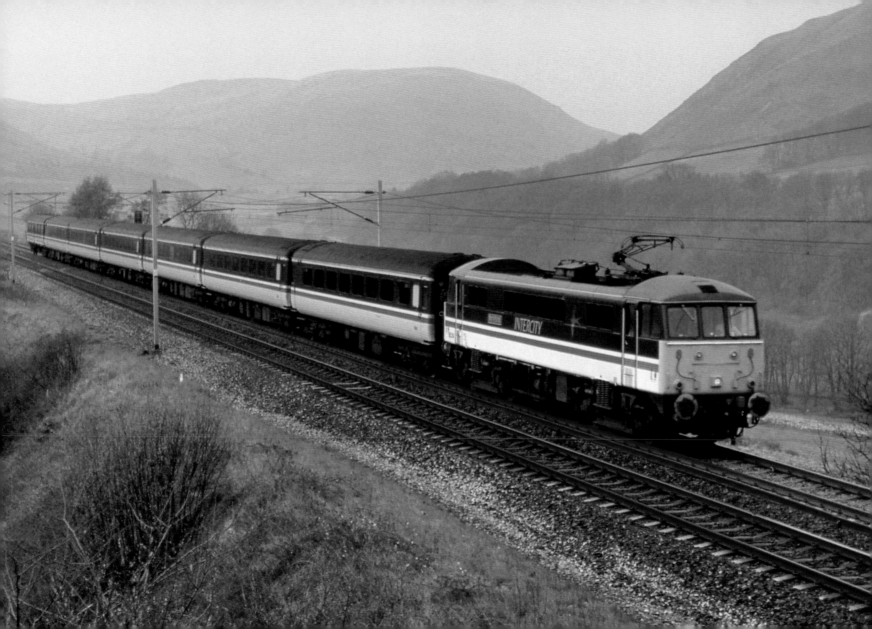

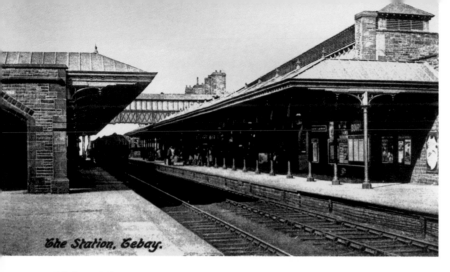

The Station, Tebay.

Left: **Tebay**

An Edwardian postcard view of Tebay station, looking northwards along the down platform. Tebay engine shed, to the west of the passenger station, had an allocation of about a dozen locomotives during the early British Railways era, half-a-dozen of these being employed as banking engines to assist heavy trains up the 1 in 75 Shap Bank. Banking engines normally 'buffered-up' to the rear of trains requiring assistance at Loups Fell, to the north of the station, and they were then able to provide additional power on the four-mile climb to Shap Summit. Large tank engines seem to have been preferred for banking duties, some examples noted on this work at various times being Fowler Class 4MT 2-6-4Ts Nos 42393, 42396, 42403, 42404 and 42424, and Fairburn Class 4MT 2-6-4Ts Nos 42095 and 42210.

Right: **Tebay**

Another postcard view from the early 1900s, showing the aforementioned engine shed and the rows of railway houses that housed a close-knit community of railwaymen and their families; some of the houses were used as 'barracks' to accommodate enginemen spending the night in Tebay.

Opposite: **Tebay**

Fowler Class 4MT 2-6-4T No. 2424 and an unidentified sister locomotive double-head a mixed freight train on the down main line at Tebay. No. 2424 was presumably returning south to Tebay after banking a northbound train up Shap Bank. The 93 target number indicates that the engine was engaged in Tebay banking and shunting duties – the numbers being displayed to establish which locomotive was being used for each duty – the details being telephoned to Control Office, which kept a record of each movement.

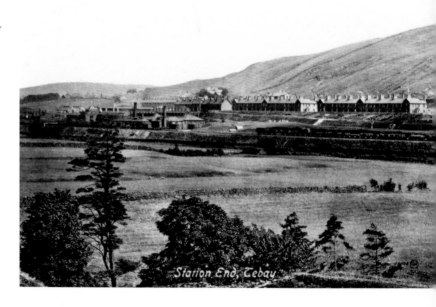

Station End, Tebay.

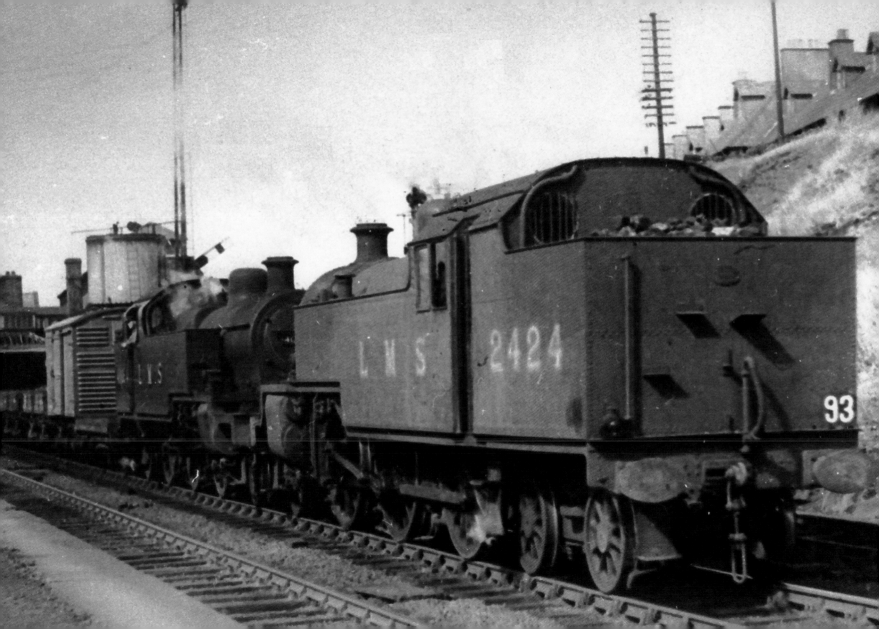

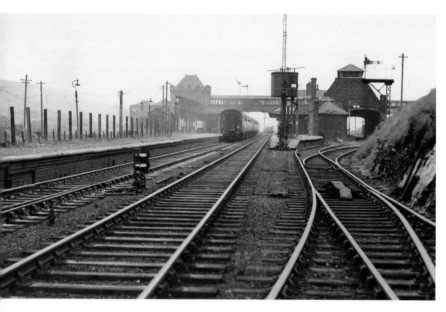

Right: **Tebay – The 2004 Accident**

A further view of Tebay station, looking north towards Carlisle. Tebay was the scene of a fatal accident that took place on 15 February 2004 when a runaway trolley loaded with 16 tons of rails ran down the 1 in 75 Shap gradient and mowed down four locally-based permanent-way men near Tebay station. The men who were killed, Colin Buckley and Darren Burgess of Carnforth, Chris Walters of Morecambe, and Gary Tindall of Tebay, are now commemorated by memorials at both Tebay and Carnforth – the Tebay memorial being sited to the south of the village near the crash site, while the Carnforth memorial is sited immediately to the north of the main station building on the up side.

Left: **Tebay**

Tebay's importance stemmed from its role as an interchange point between the Stainmore route and the West Coast Main Line. However, the Stainmore line was in decline by the British Railways period, the passenger service having been reduced to just three trains each way by 1958, and the railway was closed to all traffic with effect from 22 January 1962. This in turn resulted in a reduction in traffic at Tebay, and this once-busy junction station was closed with effect from 1 July 1968.

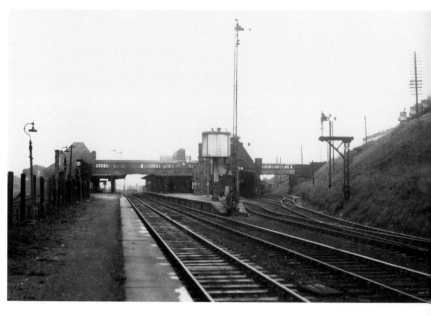

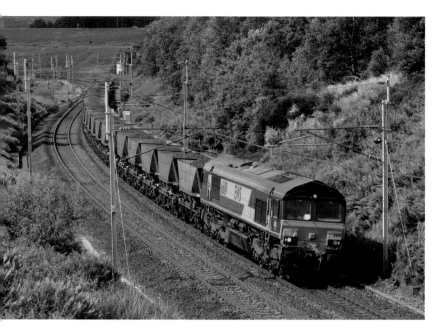

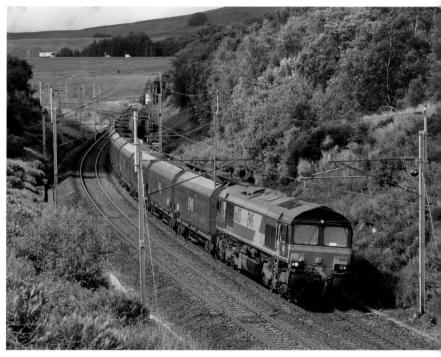

Left: **Tebay**

Class 66 locomotive No. 66119 heads southwards past Greenholme, near Tebay, on 19 June 2006 with a train load of Scottish coal for English power stations.

Right: **Tebay**

Class 66 locomotive No. 66013 weaves around the reverse curves at Greenholme with the Greenburn to Ratcliffe coal train on 19 June 2006. High capacity bogie HTA coal wagons were at that time rapidly replacing the older four wheel HAA hopper type that can be seen in the previous illustration.

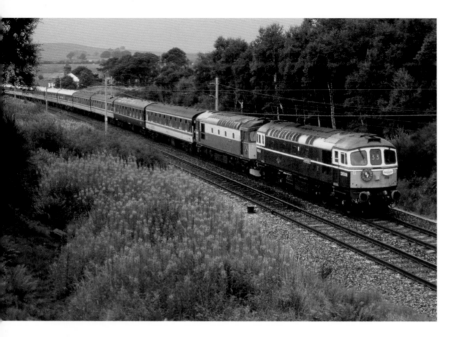

Right: Tebay
Class 66 locomotive No. 66602 swings round the reverse curves at Greenholme while hauling a southbound loaded ballast train on 19 June 2006. The split-level M6 motorway can be seen in the background.

Opposite: Tebay
Virgin 'Voyager' unit No. 220022 *Brighton Voyager* heads northwards during a brief sunny spell at Greenholme while working the 10.46 a.m. Bournemouth to Edinburgh Virgin CrossCountry service on 19 June 2006. The fells that can be seen in the background look ominously dark!

Left: Tebay
Class 33 locomotives Nos 33008 *Eastleigh* and 33026 *Seafire* pass Greenholme with the Pathfinder Tours 6.34 p.m. Carlisle to Bristol Temple Meads Crompton Crusader rail tour on 30 July 1995.

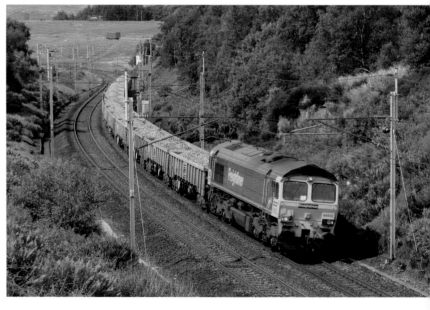

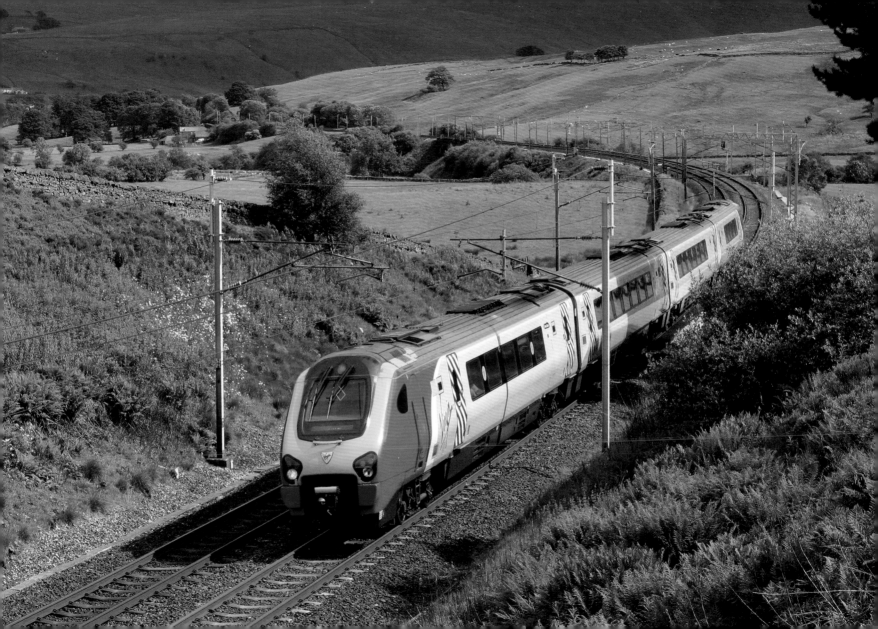

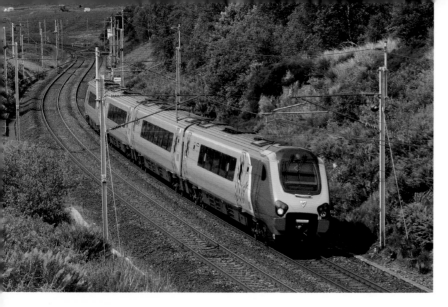

Right: Tebay

Class 50 locomotives Nos 50031 *Hood* and 50049 *Defiance* head southwards along the West Coast Main Line at Greenholme with the 8.15 a.m. Inverness to Swindon Pathfinder Tours Orcadian working on Sunday 19 June 2006. The locomotives, in BR 'large logo' blue livery, were masquerading as scrapped sister 66 Nos 50028 *Tiger* and 50012 *Benbow* respectively. This was the return leg of a marathon Scottish tour that had started on Friday 16 June, and involved trips to Kyle of Lochalsh, Wick and Thurso.

Opposite: Shap – Passing Greenholme

A solitary sheep grazing in the field at Greenholme pays no attention whatsoever as Class 50 locomotives Nos 50007 *Sir Edward Elgar* and D400 sweep past with the Waterloo to Carlisle Carlisle Fifty Farewell rail tour on 11 April 1992.

Left: Tebay

Virgin Voyager unit No. 220010 *Ribble* runs through the reverse curves at Greenholme on 19 June 2006 with the 12.52 p.m. Edinburgh to Bournemouth Virgin CrossCountry service on 19 June 2006. This Voyager unit was later transferred to Cross Country Trains, after which its name was removed.

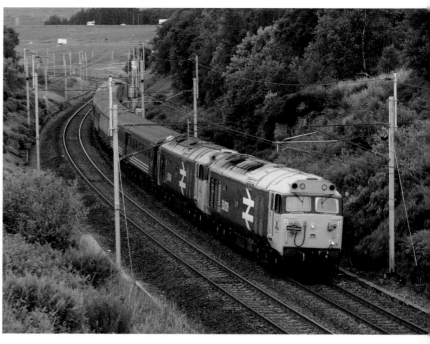

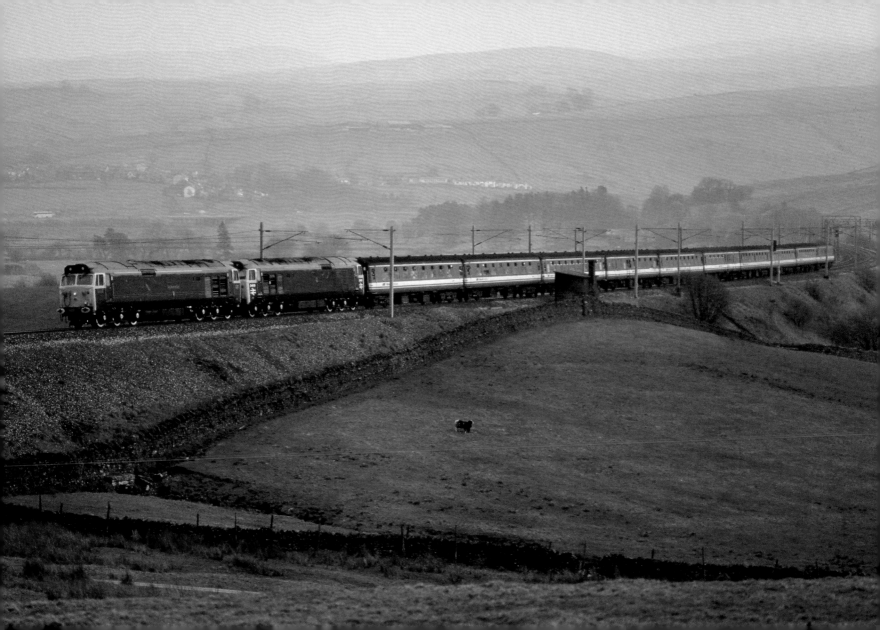

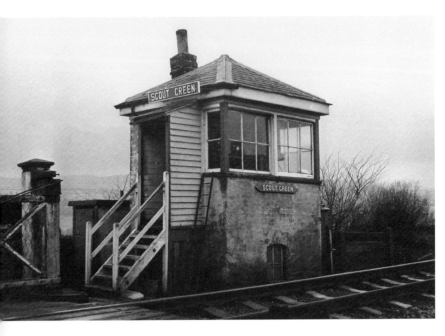

Right: Shap – Passing Scout Green

Class 52 diesel-hydraulic locomotive No. D1015 *Western Champion* races down the grade at Scout Green with the 3.30 p.m. Pathfinder Tours Carlisle to Bristol Temple Meads Western Heights excursion on 3 September 2005; this was the return leg of a Bristol to Carlisle rail tour – the northwards journey having involved a trip on the Settle and Carlisle line. Shap was of course the scene of countless railway photographs from the last days of steam, as heavy freights were banked up the 1 in 75 gradient from Tebay to Shap Summit. No. D1015 was built at Swindon in 1963 and withdrawn by BR in 1976; it is now owned by the Diesel Traction Group, and is normally kept on the Severn Valley Railway.

Left: Shap – Scout Green Signal Box

Northbound trains approaching Shap summit are faced with over four miles of continually-rising 1 in 75 gradients as the line runs through desolate moorland, which can be particularly grim during the winter months. As trains approach the summit they pass an isolated level crossing at Scout Green. The crossing was protected by a diminutive signal cabin of archaic appearance, which was similar to other boxes found on the Lancaster and Carlisle section. It was of rendered brick construction, with a pyramidal slated roof and small-paned window frames. From Scout Green crossing the route continues to Shap Summit, where another box was provided on the up side to control a relatively complex system of loops and sidings, one of which served the Shap Granite Co. The actual summit is 916 feet above mean sea level.

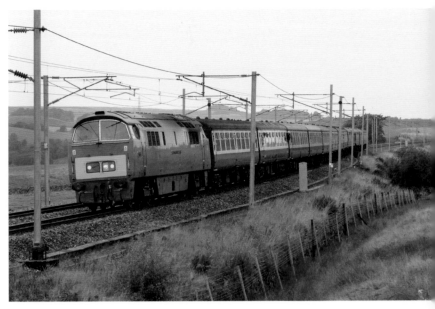

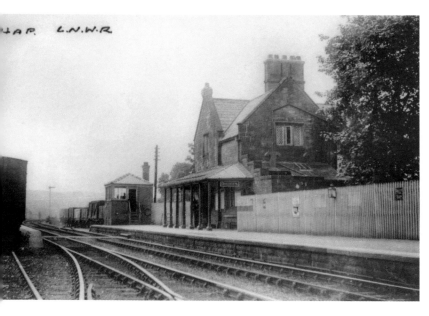

Left: Shap
Having surmounted Shap Summit, trains descend towards Shap station on a brief stretch of 1 in 106, beyond which the falling gradients ease to 1 in 125. Shap station (269.75 miles) was some 850 feet above mean sea level.
The station was opened on 17 December 1846 and closed with effect from 1 July 1968. The infrastructure provided at this remote outpost consisted of slightly-staggered up and down platforms with a two-storey station building on the down side and a subsidiary waiting room on the up platform. The platforms were linked by a plate girder footbridge, and there were dead-end sidings on both sides of the running lines, both sidings being equipped with short, dead-end spurs.

Right: Shap
A general view of Shap station, looking south towards London, probably during the British Railways period around 1960. The main station building is visible beyond the footbridge, and the up siding and its 'kick-back' spur can be seen to the left – the spur being entered by means of a reverse shunt from the main siding. The cattle loading pens were situated on the loading bank, while the goods shed was sited beside the down spur on the opposite side of the line. The latter structure was a small, timber-framed structure standing on a trestle platform.

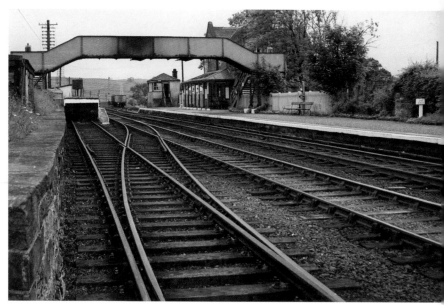

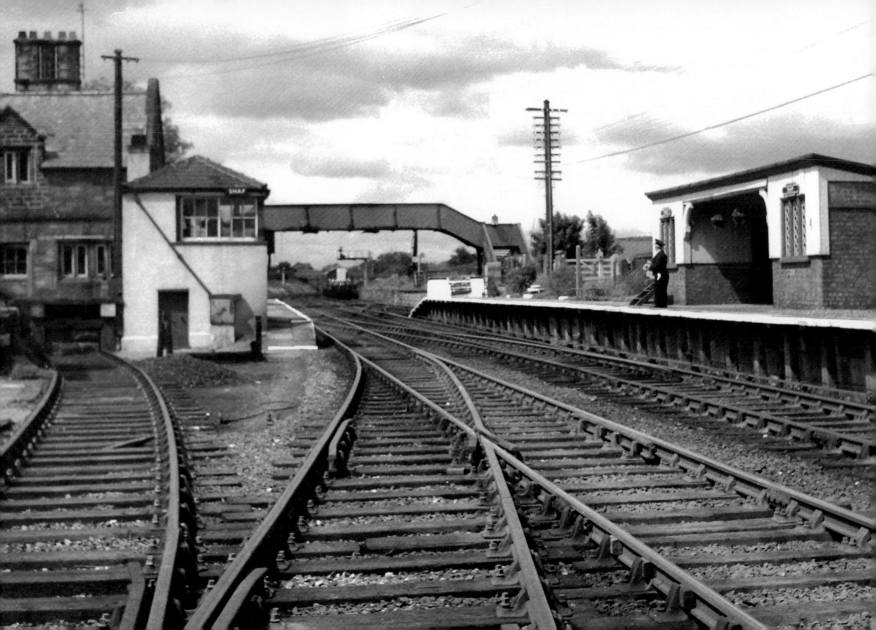

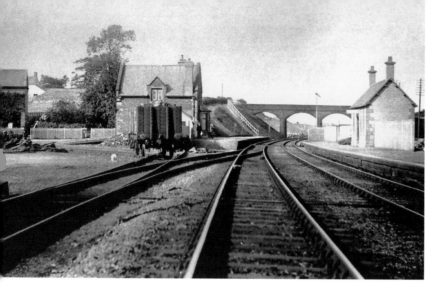

Left: Clifton & Lowther

Still falling at 1 in 125, the line continues northwards to Clifton and Lowther. Another small station was provided here, and in 1862 this otherwise unimportant wayside stopping place briefly served as the junction for the Eden Valley line.

Right: Clifton and Lowther

Clifton and Lowther station was fully equipped with a range of accommodation for coal, livestock and general merchandise traffic, and there was, in addition a 4-ton yard crane. A private siding at Lowther, to the south of the station, served Lord Lonsdale's Timber Yard. Mention of the Lonsdales serves as a reminder that Hugh, the fifth Earl Lonsdale, resided in nearby Lowther Castle and entertained on a most extravagant scale. The Castle was in fact a nineteenth-century country house which, in its heyday, brought considerable traffic to Clifton and Lowther station. Sadly, Clifton and Lowther was an early victim of rationalisation, and the station closed as long ago as 1938, while Lowther Castle was partially demolished during the 1950s.

Opposite: Shap

A general view of the station, looking north towards Carlisle around 1960. The signal cabin, which was similar to that at Scout Green, can be seen at the south end of the down platform, while the photograph also shows the small, brick-and-timber building on the up side. The latter structure incorporated two small waiting rooms on either side of an open-fronted waiting area – the building being distinguished by the provision of ornamental 'diamond pane' windows.

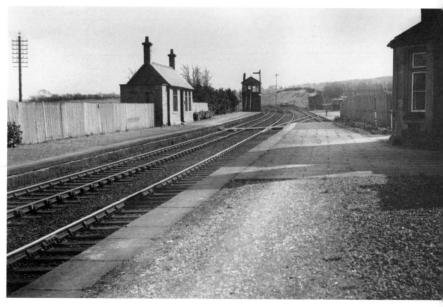

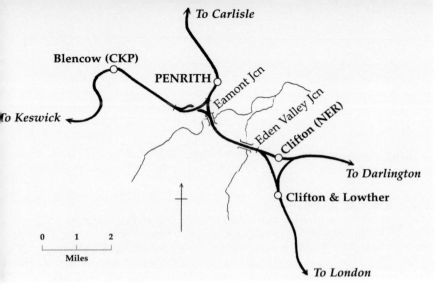

Left: **Clifton and Lowther – Junctions around Clifton and Penrith**
Leaving Clifton and Lowther, northbound workings reach the site of Eden Valley Junction, where the Eden Valley route formerly converged from the east. The accompanying sketch map shows the system of junctions around Clifton and Penrith, the Stainmore route to Darlington being to the right, while the Cockermouth, Keswick & Penrith Railway diverges to the west. When opened in 1862 the Eden Valley line had joined the West Coast Main Line via a southwards-facing connection that was unsuitable for through running into Penrith station. However, the opening of an east-to-north curve in August 1863 allowed passenger trains from the Eden Valley route to run to and from Penrith, and Clifton and Lowther thereby lost much of its importance as a junction station. Interestingly, the original east-to-south curve was not immediately abolished, and there was, for a time, a triangular junction to the north of the station. The south-facing curve was finally abandoned in 1874.

Right: **Penrith for Ullswater – Junction for Keswick**
Turning north-westwards, trains cross the River Lowther on the Lowther Viaduct. The viaduct, of stone construction, has six 60-foot spans. After crossing the viaduct, the line passes through cuttings and, curving northwards, the railway is then carried over the River Eamont on a second viaduct with five stone arches. Eamont Bridge Junction was sited immediately to the north of the viaduct; here, the Cockermouth, Keswick and Penrith route joined the West Coast Main Line. The junction faced west towards Keswick, a south-to-west curve being provided so that mineral trains could reach the CK&PR line without reversing in Penrith station. The curve was arranged as a burrowing junction, and it joined the Keswick route at Redhills Junction. Beyond, the main line runs north-eastwards into Penrith station (281.25 miles), which is sited on the western edge of the town, within sight of Penrith Castle. The accompanying photograph shows the station during the early 1900s.

Opposite: **Penrith for Ullswater**
A detailed view of the main station building.

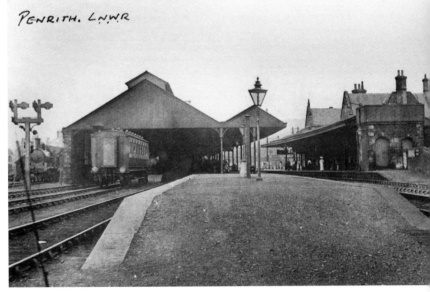

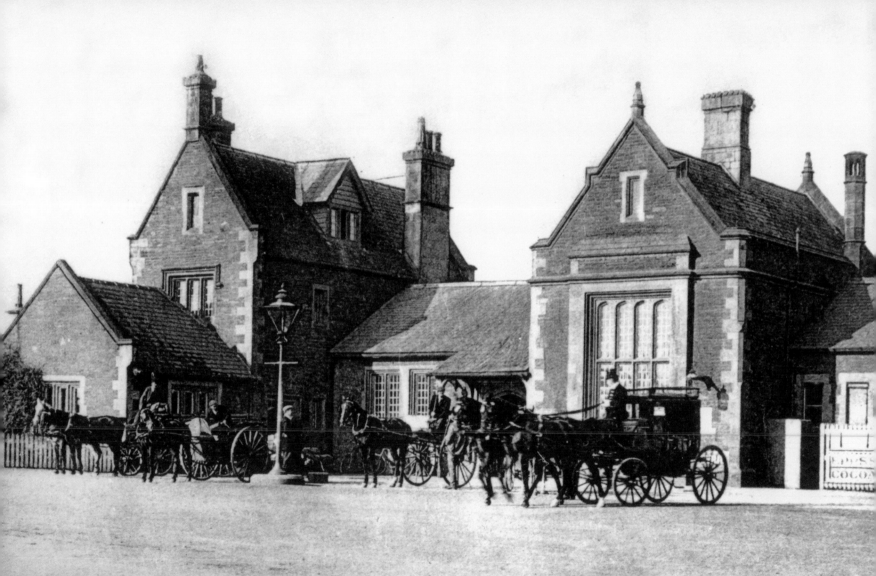

PENRITH L.N.W.R.

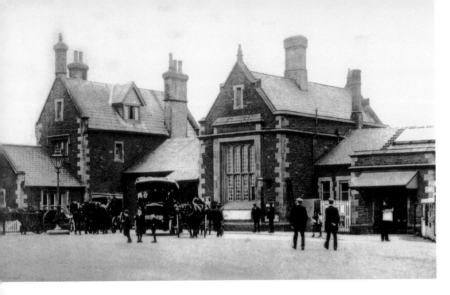

Left: Penrith for Ullswater – The Main Station Building

When opened in 1846, Penrith station had boasted one of Sir William Tite's romantic Gothic-style station buildings. A print which appeared in *The Illustrated London News* depicted the station as an H-plan building with two cross wings linked by a much lower central block. The northernmost wing featured a huge mullioned and transomed window which evidently provided illumination for the booking hall, while the corresponding wing at the south end of the building incorporated a two-storey station master's house. Both wings sported ornate Tudor gables, the gable of the house portion being set back from the platform to produce a staggered ground plan. The two cross wings were physically connected by a single-storey service block, which was partially hidden behind a covered waiting area. In later years the station was considerably enlarged, with additional buildings and extensive new canopies. These LNWR additions and extensions have masked, but not entirely obscured, the original Lancaster and Carlisle building, which could still be seen behind the later platform coverings.

Right: Penrith for Ullswater

Prior to rationalisation the station had been provided with three platforms, as shown in this view from around 1960. The down platform was an island with an outer face for Keswick branch trains (now removed), while the main station building is on the up side. The up and down platforms are linked by an underline subway, and the B5288 road is carried across the line on an overbridge to the north of the platform. Although a comparatively small station, Penrith was well-equipped with running loops and sidings. There were up and down running loops at Clifton Junction and Eamont Bridge Junction, while further loops and sidings extended northwards between Eamont Bridge and Penrith station. The goods yard incorporated the usual range of facilities for coal, livestock and general merchandise traffic, and there was a large goods shed and a 5-ton yard crane for timber or other heavy consignments. The station was equipped with watering facilities, the water being supplied from a large tank house at the north end of the down platform.

Opposite: Penrith for Ullswater

Stanier Class 8F 2-8-0 No. 48366 hauls a mixed freight train southwards through Penrith station.

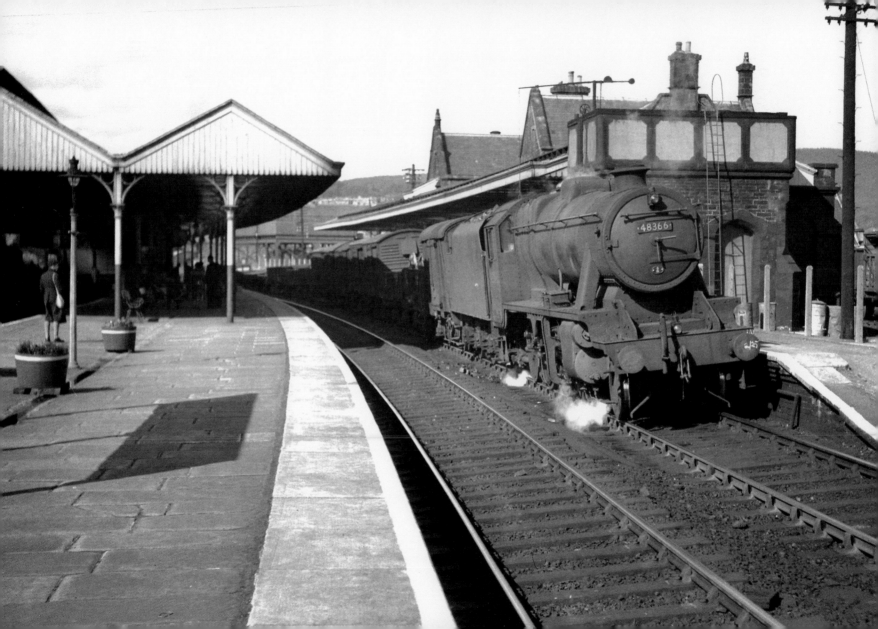

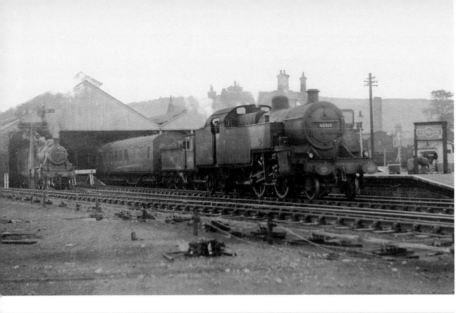

Penrith for Ullswater

In steam days the layout at the south end of the station had been particularly impressive. The southern approaches to Penrith were remodelled in the 1890s, when new up and down main lines were installed and the old main line became a goods loop. Further changes were put into effect in 1937, when Eamont Bridge Junction was simplified, the south-to-west curve being removed, leaving the north-to-west loop which was used by CK & PR passenger trains as the only connection between the Keswick route and the West Coast Main Line.

The facilities at Penrith included a two-road engine shed, which was situated on the down side between the running lines and the Keswick branch. The track layout was arranged in such a way that engines could reach the shed from the adjacent Keswick branch, or from the direction of the station. Penrith shed was coded 12C until 1955, and 12B from 1955 until 1958. In the early 1950s its allocation included Fowler Class 4F 0-6-0 No. 44086, Ivatt Class 2MTs Nos 46449 and 46455, and Webb Cauliflower 0-6-0s Nos 58389, 58409 and 58412.

Penrith station was signalled from three signal boxes, which were known as Penrith No. 1, Penrith No. 2 and Penrith No. 3 boxes. No. 1 box was sited on the down side near the junction with the Keswick branch. No. 2 box was twenty-one chains to the north, in convenient proximity to the engine shed and yards, while Penrith No. 3 box was situated on the up side, beyond the end of the up platform. Nos 1 and 2 boxes were standard LNWR brick and timber cabins with typical 'flat-sided' gables; boxes of this same basic type were erected all over the North Western system until about 1902, when the gable design was altered. Penrith No. 3 box, in contrast, was a tall brick box with a pyramidal roof.

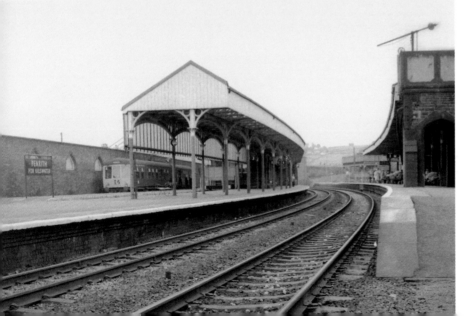

Penrith – The Keswick Branch

The Keswick to Penrith line became a dead-end branch following the closure of the western section of the Cockermouth, Keswick and Penrith route in 1966. In the next few months the line was further down-graded, the goods yards being closed, while the passing loops were lifted and the stations were reduced to unstaffed halts. Many of these measures were false economies; with no run-round loop at Keswick, for example, it became difficult to run excursions, and a useful source of additional traffic was thrown away. The upper view shows the west end of Keswick station prior to rationalisation, whereas the two lower photographs were taken in the early 1970s, by which time only one platform remained in use. Not surprisingly, traffic on the Keswick route declined still further, and it was announced that the branch would be closed to all traffic from Monday 6 March 1972.

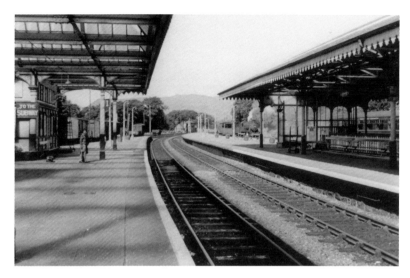

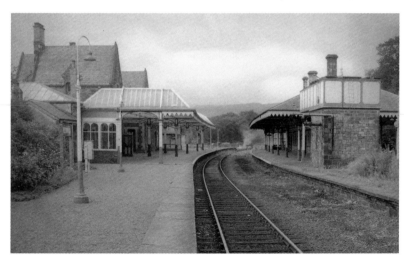

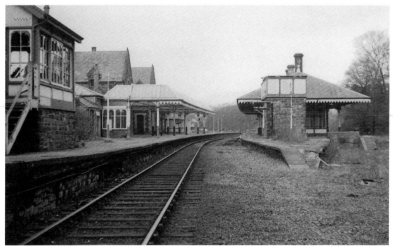

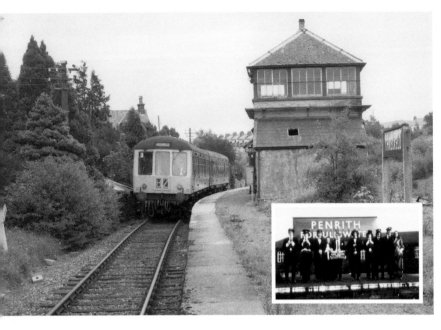

Right: Penrith – Some Tickets

A selection of LNWR, LMS and BR tickets from the Carnforth to Penrith section of the West Coast Main Line, including London & North Western Railway third class singles from Carnforth and Tebay, and a machine-issued BR platform ticket from Penrith. The pale red ticket (bottom right) was used on the last train from Keswick on 4 March 1972.

Left: Penrith – The Keswick Branch

A 2-car multiple unit comes to a stand in Threlkeld station during the final months of operation on the Keswick branch. The last trains ran on Saturday 4 March 1972, the final working being an eight-car diesel multiple unit special that had been organised by Keswick Round Table, and was timetabled to leave Keswick at 10.05 p.m. Some 450 people made this sad, nocturnal journey, while countless others watched silently from the lineside as 108 years of railway history drew inexorably to a close. A local newspaper reported that 'women wept on station platforms' as the very last train made its way to Penrith. The scene was completed by a Victorian mourning party from the University of Lancaster who wore funereal black frock coats as a satirical comment on BR's decision to let the Cockermouth, Keswick & Penrith Railway die.

Inset: The Victorian mourning party at Penrith station, with the 'last service train' headboard.

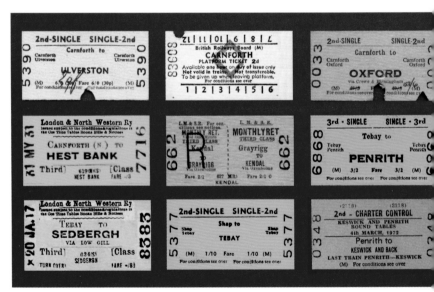

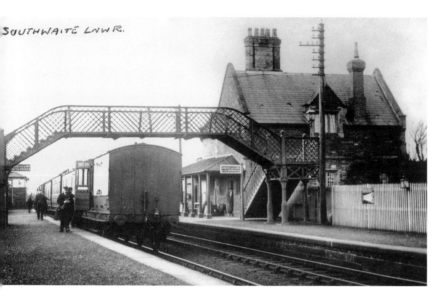

SOUTHWAITE LNWR.

Left: Southwaite

From Penrith, the route heads north-north-eastwards, the gradients on this section being generally favourable, although down workings are faced with a brief ascent before the line resumes its descent towards Carlisle. There are five closed stopping places on this part of the route, including Plumpton (286 miles) and Calthwaite (288.5 miles), which were opened in 1846 and 1854 respectively. Plumpton was closed with effect from 31 May 1948, while Calthwaite was deleted from the railway system with effect from 7 April 1952. Plumpton remained open for goods traffic until 1964, and in 1968 the goods yard was temporarily re-opened for motorway construction traffic. Falling at 1 in 228, the route continues to Southwaite (291.75 miles), a small station that was opened on 17 December 1846 and closed with effect from 7 April 1952. The infrastructure at this abandoned stopping place included a picturesque, Tudor-gothic station building of the now-familiar kind, which has survived as a private house and can be seen on the up side as trains rush past.

Right: Wreay

When the Lancaster and Carlisle line was under construction it was envisaged that the penultimate stopping place en route to Carlisle would be at Newbiggin and Wreay, but these plans were amended, and when opened in December 1846 an alternative station was provided at Brisco, about three miles to the south of Carlisle. Brisco disappeared from the timetables just six years later and Wreay was opened in its place on 1 December 1852. On 27 June 1854 *The Times* reported that Miss Irving, a twenty-one-year old female passenger, had died as a result of falling 15 feet from a bridge without parapets – no fencing or platform lighting having been provided at Wreay because the station had initially been regarded merely as a temporary stopping place 'to see if it would answer any better'. Contemporary news reports pointed out, disapprovingly, that the Lancaster & Carlisle Railway was 'perhaps the most prosperous in the kingdom, with the least possible excuse for parsimony'. The illustration shows Wreay station during the Edwardian period. The station was closed in August 1943.

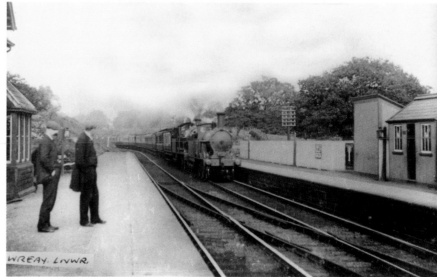

WREAY. LNWR.

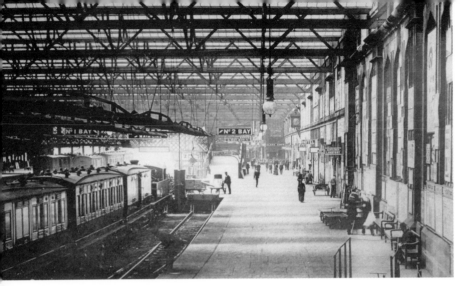

Carlisle Citadel – Origins of the Station

Nearing Carlisle, trains continue northwards along a web of trackwork before coming to rest in the platforms at Carlisle Citadel station, some 299 miles from London Euston and 102.25 miles from Glasgow. In pre-Grouping days, Carlisle Citadel was a unique station, which was used by the trains of no less than seven pre-Grouping railways – the companies concerned being the London & North Western, Caledonian, Midland, Glasgow & South Western, North British, North Eastern and Maryport & Carlisle railways.

The station was opened in 1847 and it had, at first, been envisaged that the cost of its construction would be shared between the Lancaster & Carlisle, Caledonian, Newcastle & Carlisle and Maryport & Carlisle companies. Unfortunately, the companies involved were unable to reach an amicable agreement, and most of the money was contributed by the Lancaster & Carlisle Railway. This was, understandably, a source of much ill-feeling between the various undertakings that used the station, but the problems at Carlisle were finally resolved by the creation of the Carlisle Citadel Joint Station Committee, which was set up under the provisions of an Act of Parliament obtained on 22 July 1861. A further Act, obtained on 21 July 1871, provided for an enlargement of the station in connection with the Midland Railway, which shared in the operation of Carlisle Citadel from 1876 onwards, following the opening of the Settle and Carlisle line.

The photographs, both of which were copied from Edwardian postcards, show the interior of the train shed around 1908.

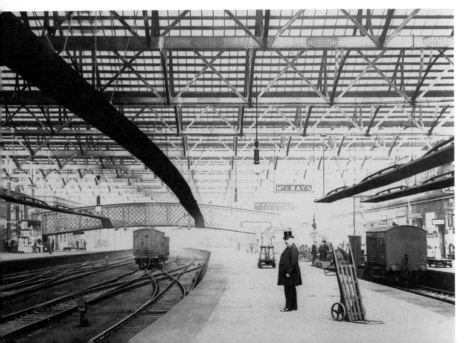

Station.
Carlisle.

Left: Carlisle Citadel - The Station Buildings

The elaborate station buildings were designed by Sir William Tite, who adopted the 'Tudor-gothic' style of architecture, as shown in this Edwardian postcard view. The main station building, on the up side, is an ornate structure incorporating a large *porte-cochère* and a prominent clock tower, while the platforms are covered, for much of their length, by an overall roof which consists of a series of transverse ridge-and-furrow bays. Part of the roof structure was dismantled in 1957-58, leaving a massive retaining wall in situ on the western side of the station. The main façade is adorned with coats-of-arms, the Royal arms in the centre being flanked by those of the Lancaster & Carlisle Railway and the Caledonian Railway. The two remaining panels were intended to display the arms of the Maryport & Carlisle Railway and the Newcastle & Carlisle Railway, but as these two undertakings had stubbornly refused to contribute towards the cost of the station, the two panels were deliberately left blank.

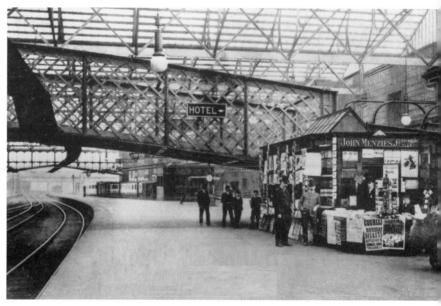

Right: Carlisle Citadel - Platform Arrangements

The station has eight platforms, three of these being through platforms, while the remaining five are terminal bays. Platforms 1 and 3, on the down side, are the two faces of a very wide island platform, while Platform 4 is the main platform on the up, or east side; all three platforms are now signalled for bi-directional working. Platform 2 is a terminal bay at the south end of the island platform, while Platforms 5 and 6 are south-facing bays on the up side, and Nos 7 and 8 are north-facing bays on the up side of the station. Additional through lines are provided between Platforms 3 and 4, and in steam days these were equipped with intermediate cross-overs so that, if necessary, locomotives could be changed – Carlisle being the place an which the main Anglo–Scottish expresses changed locomotives. Four further tracks are available for stabling purposes on the west side, and the platforms are linked by a wide footbridge, which can be seen in this view taken around 1910.

Carlisle Citadel – Postcard Views

Left: A postcard view of Carlisle Citadel station showing the interior of the train shed, looking south towards London around 1910.

Below left: An unidentified 4-6-0 locomotive leaves Carlisle with an express passenger train during the LMS era, around 1930.

Below right: A double-headed Midland Railway express leaves Carlisle.

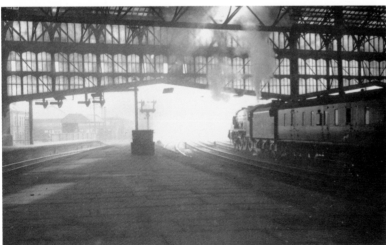

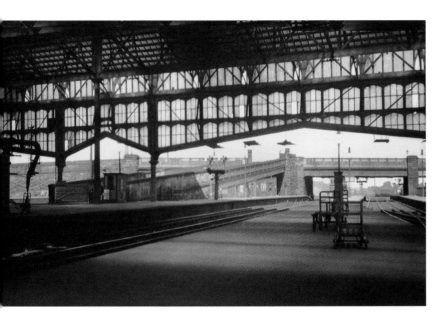

Right: **Carlisle Citadel**
A Midland Railway express leaves Carlisle behind an unidentified
Class 3 4-4-0 locomotive.

Left: **Carlisle Citadel**
An interior view of the train shed, looking north towards Glasgow during
the British Railways period, probably around 1962.

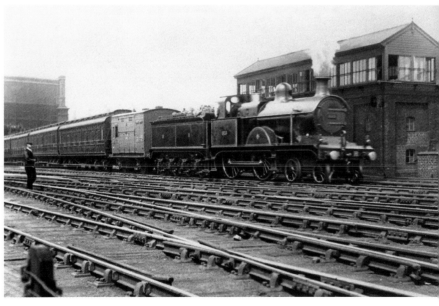

Right: Carlisle Citadel

The M&CR had its own locomotive shed at Carlisle Currock, the building concerned being a three-road structure with a gable roof. This view, circa 1905, shows M&CR 2-4-0 No. 8 and 0-4-2 No. 4 standing outside the shed. No. 8 was built in 1876 as one of a class of three passenger locomotives designed by Hugh Smellie. It remained in service until 1925, by which time it had become LMS No. 10006. No. 4 was constructed in 1879 as one of six 0-4-2 locomotives intended for mixed traffic work. It became LMS No. 10010 after the Grouping.

Opposite: Carlisle Citadel

A broadside view of Maryport and Carlisle 0-4-2 No. 2, photographed in the M&CR Bay at Carlisle Citadel on 12 October 1894. Designed by Hugh Smellie, this locomotive had 5 feet, 7.5 inch coupled wheels and 17 inch by 24 inch cylinders. It was rebuilt with a domed boiler around 1904 and became LMS No. 10011 after the Grouping. These engines were visually very similar to the Stirling 221 Class 0-4-2s employed on the G&SWR.

Left: Carlisle Citadel – The Maryport and Carlisle Line

With a modest system comprising just 42.75 route miles, the Maryport & Carlisle Railway was the smallest of the seven pre-Grouping railway companies that used Carlisle Citadel station. It was, nevertheless, an old and well-established undertaking, its initial section having been opened between Maryport and Arkleby Pit, near Aspatria, on 15 July 1840, while the M&C main line was completed throughout between Maryport and Carlisle on 10 February 1845. The M&CR worked its own trains, using a small fleet of (mainly) 2-4-0, 0-4-2 and 0-6-0 locomotives, one of these being 0-4-2 mixed traffic engine No. 2, which was photographed at Carlisle around 1914, after it had been rebuilt with a domed boiler. Four of these locomotives passed into LMS hands in 1923, the engines concerned being Nos 2, 4, 15 and 16, which became LMS Nos 10011, 10010, 10012 and 10013 respectively. They were built between 1879 and 1892, and rebuilt with domed boilers around 1904.

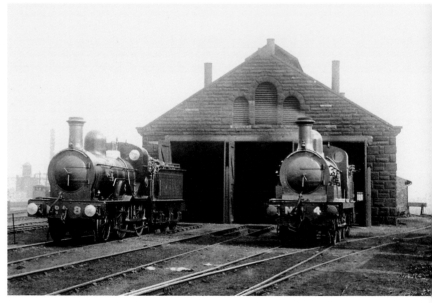

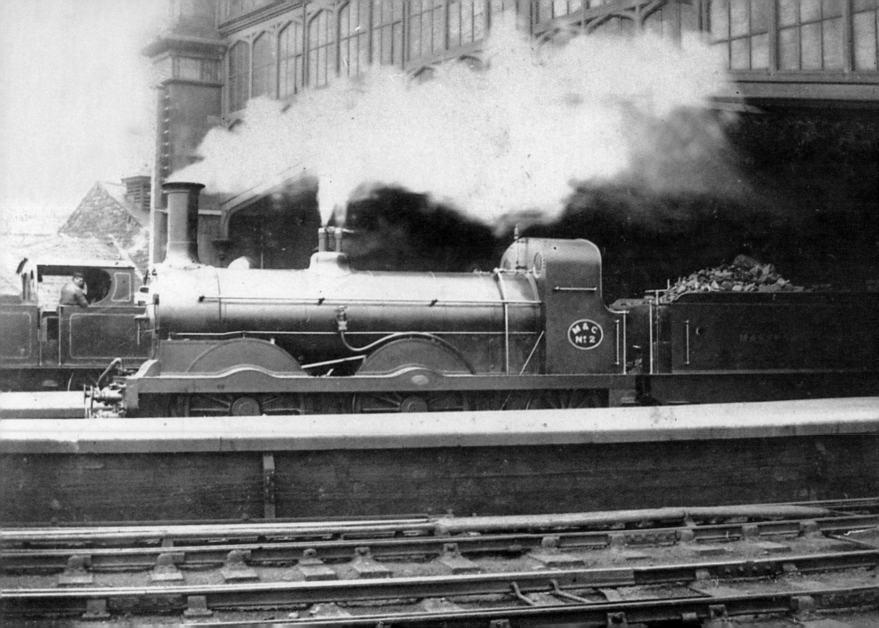

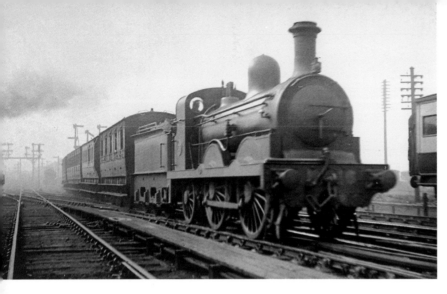

Left: Carlisle Citadel

Rebuilt Maryport and Carlisle 0-4-2 No. 16 with a passenger working near Carlisle. The railways that served Carlisle during the pre-Grouping period had distinctive liveries, Midland locomotives and rolling stock being adorned in a crimson lake livery, while Caledonian passenger locomotives were painted in a mid-blue colour scheme. Maryport and Carlisle locomotives, in contrast, were painted in a mid-green livery with red and black lining. The number plates were red, with polished brass figures, letters and borders, while lettering was applied in gold, shaded in black and dark green. The M&CR coach livery was similar to that of the Cambrian Railways, being green with white upper panels.

Right: Carlisle Citadel

Two of the rebuilt M&CR 0-4-2s at the head of a lengthy passenger train near Carlisle, the leading engine being No. 16, which became LMS No. 10013 following the Grouping.

Opposite: Carlisle Citadel

Stanier Coronation class streamlined Pacific No. 6227 *Duchess of Devonshire* at Carlisle during the LMS period. These four-cylinder locomotives were intended for sustained high-speed running on the West Coast main line between London and Glasgow. They were also designed to haul 500-ton trains up Shap and Beattock banks without assistance, though when on test in 1939 sister engine No. 6234 *Duchess of Abercorn* hauled a 600-ton train over both summits, producing power outputs that had never before been equalled in the United Kingdom. Twenty-four of the Coronation Class 4-6-2s were originally fitted with streamlined casings, and a further fourteen examples were non-streamlined. The streamlined engines were all rebuilt between 1946 and 1949, although many commentators have argued that, even in their non-streamlined state, the Stanier Pacifics were among the most impressive locomotives ever constructed.

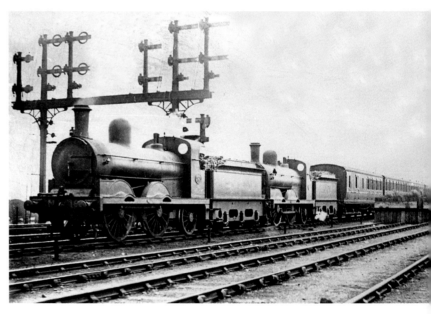

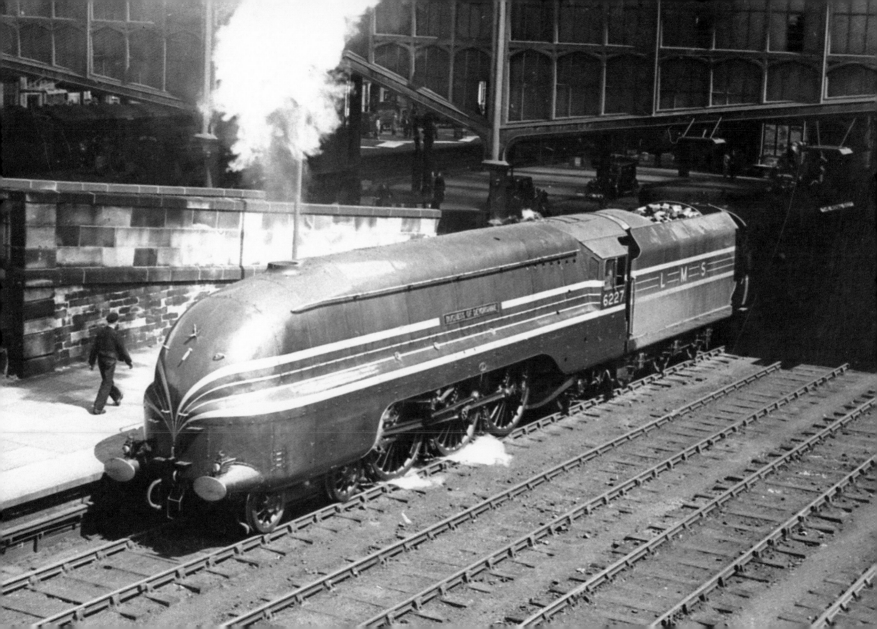

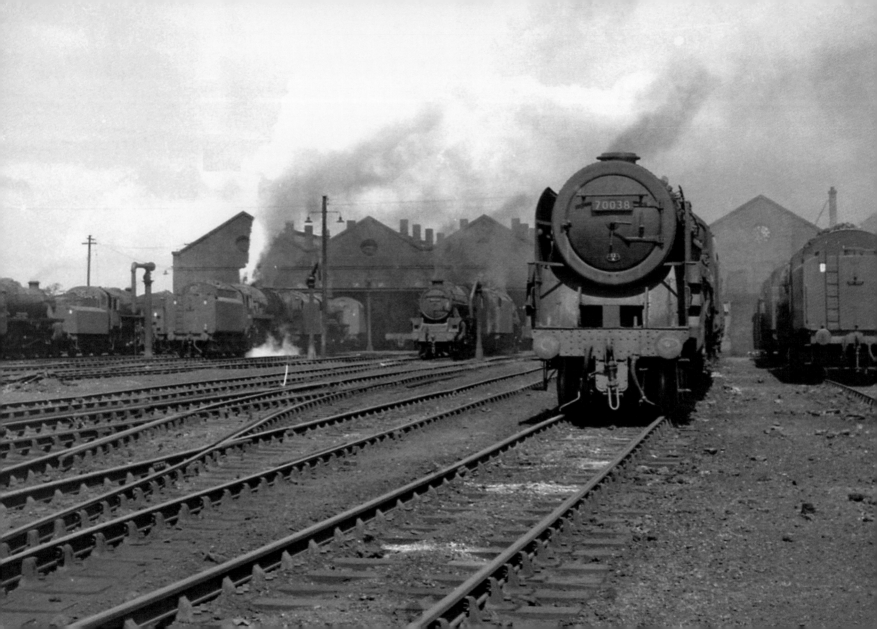

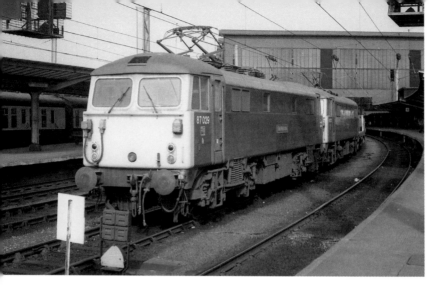

Left: Carlisle Citadel - Electric Locomotives

Class 87 electric locomotive No. 87029 *Earl Marishal* and an unidentified sister locomotive stand on the centre lines at Carlisle around 1984. Although the Class 86 and Class 87 locomotives were capable of many years further service, they were displaced from front-line passenger duties by the introduction of Pendolino units during the 1990s. Most of the Class 87 engines have now been scrapped, but No. 87029 and a number of other members of the class were exported to Bulgaria for further service. The slightly earlier Class 86s, dating from 1965–66, have fared rather better, and several examples have remained in operation as Freightliner locomotives.

Right: Carlisle Citadel

Class 37 locomotive No. 37188 awaits its next turn of duty at Carlisle Citadel. This locomotive was originally numbered D6888, and it can now be seen on the Peak Rail line in Derbyshire.

Opposite: Carlisle Kingmoor Shed

As a result of Carlisle's complicated pre-Grouping legacy, this busy rail centre acquired a range of railway facilities – each of the seven companies that had once shared the station having provided its own infrastructure. As late as the 1960s, for example, there were still three large motive power depots, Carlisle Upperby being the former London and North Western shed, while Carlisle Canal had once served the North British Railway. However, the most important shed was perhaps the former Caledonian Railway depot at Carlisle Kingmoor, which had an allocation of around 140 locomotives during the 1950s and early 1960s. This *c.* 1960 photograph shows the southern end of the shed, with Britannia Class 4-6-2 No. 70038 *Robin Hood* to the right of the picture. The steam shed was closed in 1968, but a diesel depot was subsequently built on the opposite side of the line, and the present-day Carlisle Kingmoor Traction Maintenance Depot is now used by DRS.

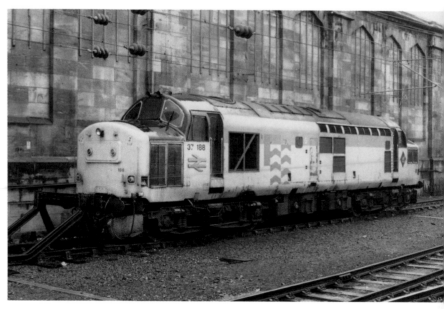

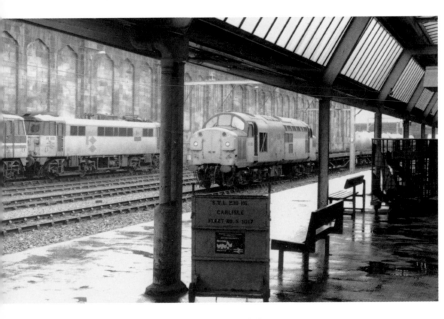

Right: Carlisle Citadel – Some Tickets

An assemblage of tickets from the Penrith to Carlisle section of the Lancaster and Carlisle route, including three machine-issued platform tickets from the BR period, and six Edmondson card tickets. The BR cheap day and special cheap day returns from Carlisle to Oxenholme and from Carlisle to Penrith are unusual in that the outward half is on the left, rather than the right, as would normally have been the case. For this reason, the red 'D' overprint appears on the 'wrong' side of the ticket.

Left: Carlisle Citadel

A platform scene at Carlisle Citadel in April 1984. Class 37 diesel locomotive No. 37100 and Class 86 electric locomotive No. 86632 await their next turns of duty in the sidings on the western side of the station, while Class 37 No. 37100 pauses on its way south with a bulk oil train.